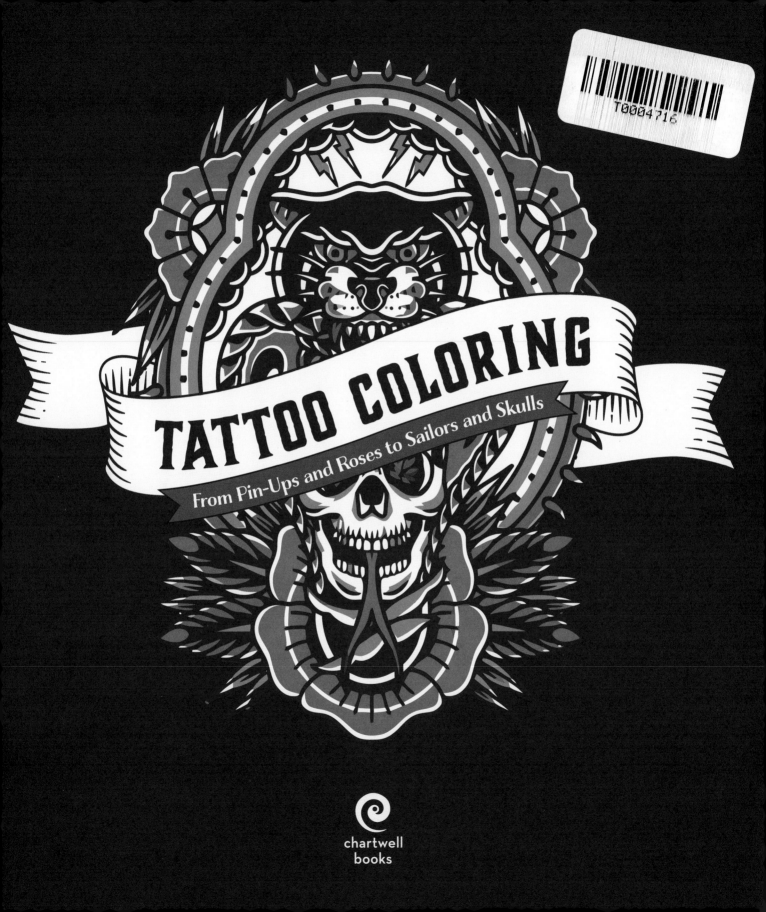

# TATTOO COLORING

From Pin-Ups and Roses to Sailors and Skulls

chartwell
books

# Tattoos are as unique as the people who get them.

These permanent skin designs can be traced back thousands of years and across cultures. They have quite literally come a long way. Once a counterculture symbol of our modern era, they've transcended social class and entered the mainstream. Today, teachers, attorneys, professional athletes, musicians, and everyone in between are sporting the many styles of their ink.

When the uninitiated think of tattoos, many will conjure up traditional or old school tatts. These are the OG tattoos, the kind you'd see on Grandpa from his time in the Navy or on the biker filling up at the gas pump: pin-ups, anchors, hearts with "mom" written across, maybe a dagger through a rose; the lines are bold, and the colors are bright. In reality, our contemporary ink can be any style we put our minds to: fine-line, watercolor, blackwork, black and grey, tribal, ignorant, cartoon, 3D, abstract, realistic, patchwork—the list goes on.

But aside from looking cool, what's the draw? Why do people subject themselves to thousands of pin pricks in their skin? Believe it or not, tattoos on mummies suggest the ink might have had therapeutic uses: marks on the abdomen may have been to ease pain during childbirth, while marks on ankles and knees could have soothed arthritis. While we can't know that for sure, we can experience our own "tattoo therapy" today. Specifically, the little bit of pain involved in getting a tattoo causes the body to release endorphins; dubbed the body's natural painkillers, endorphins also help reduce stress and improve a sense of well-being.

Just like coloring! Though hopefully there's no pain involved, the simple act of coloring similarly calms the mind and helps you unwind. Whether you're coloring or getting inked, your mind is focused on the task at hand; you put down your phone and tune out all the noise and distractions of the world. And, like sitting with a tattooist to sort out the tatt you're going to get, this coloring book is designed to help you explore your own personal creative side.

Just as there is no right or wrong way to add color to your body, there is no right or wrong way to use this book. You can color in these gorgeous illustrations however you wish and in whatever way feels right to you. One of the great things about coloring is that it's accessible to anyone, regardless of artistic capabilities. Being able to add your own colors helps make it more personal, and, unlike with a fresh tattoo, there's no pressure to make these drawings perfect.

So, while you may be contemplating your next (or first!) tattoo design, there's no time like now to turn the page and get coloring!

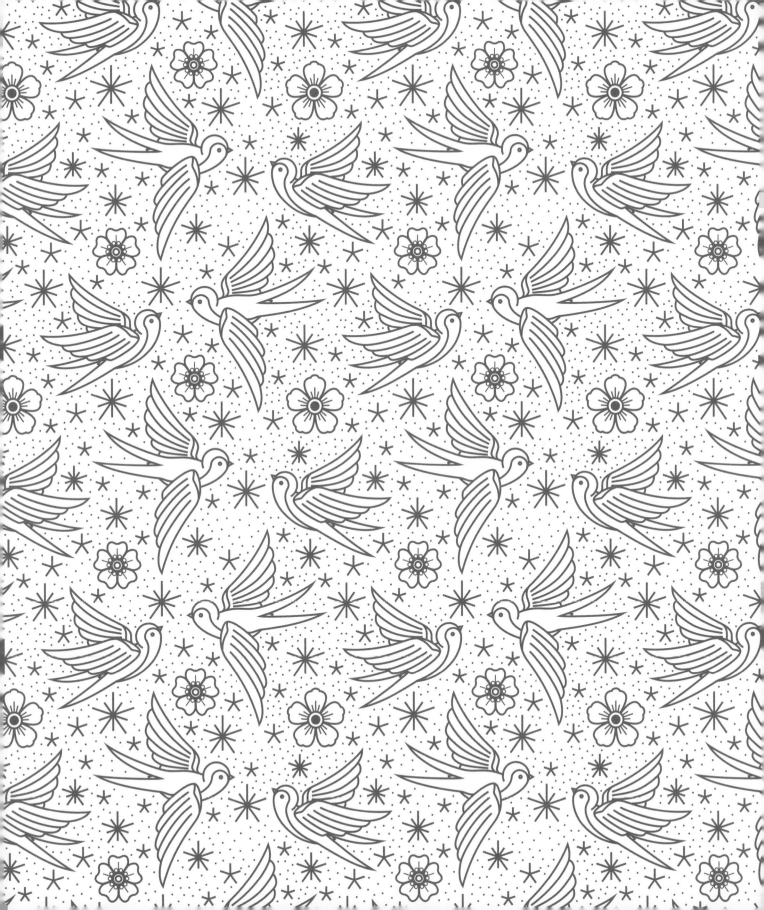

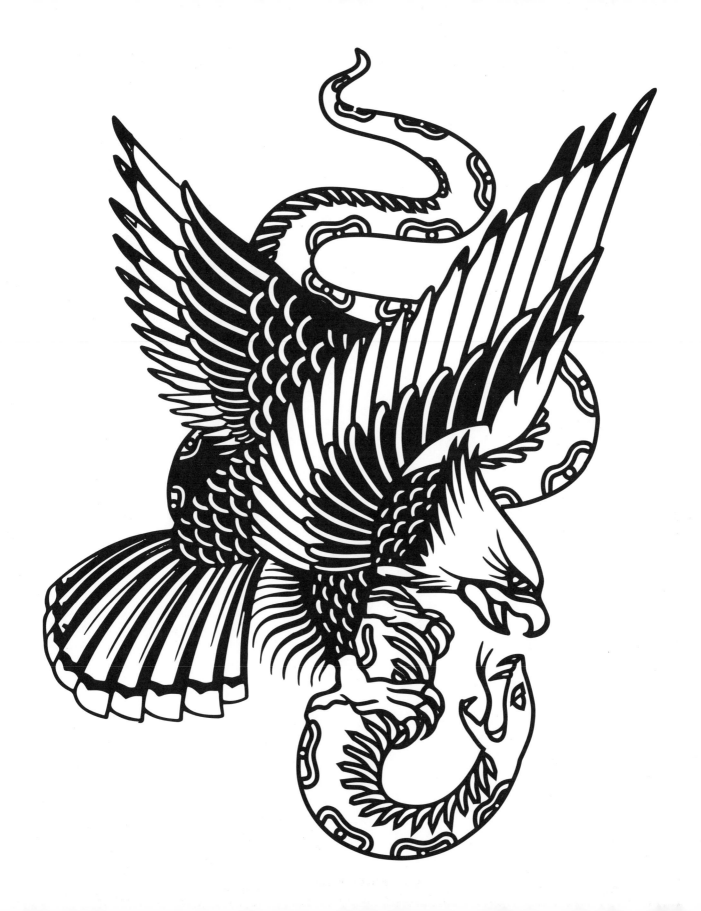

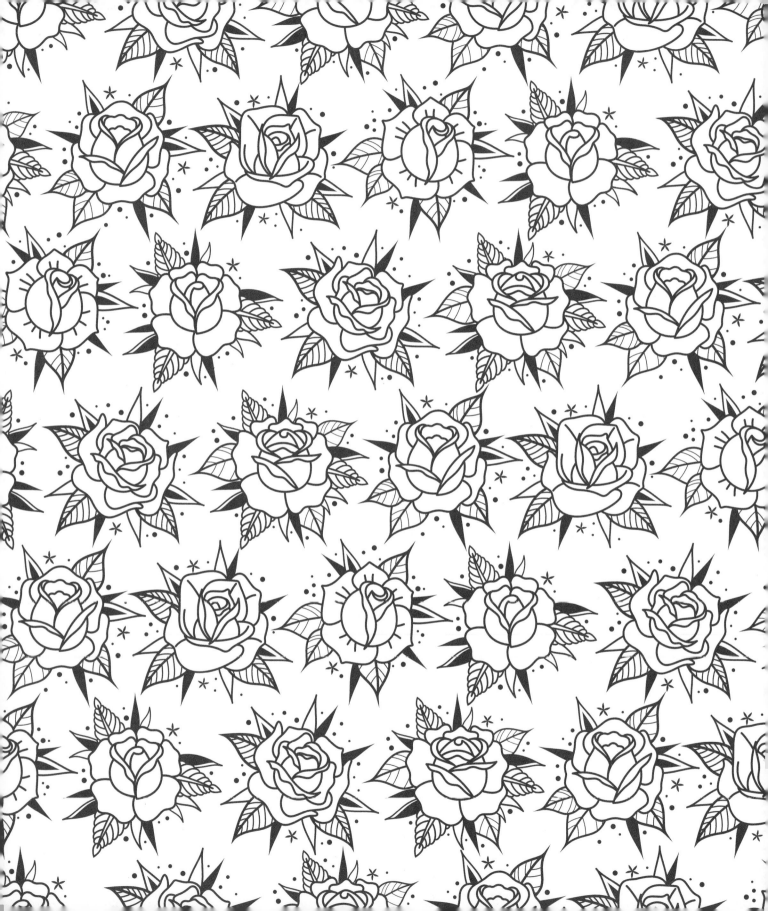

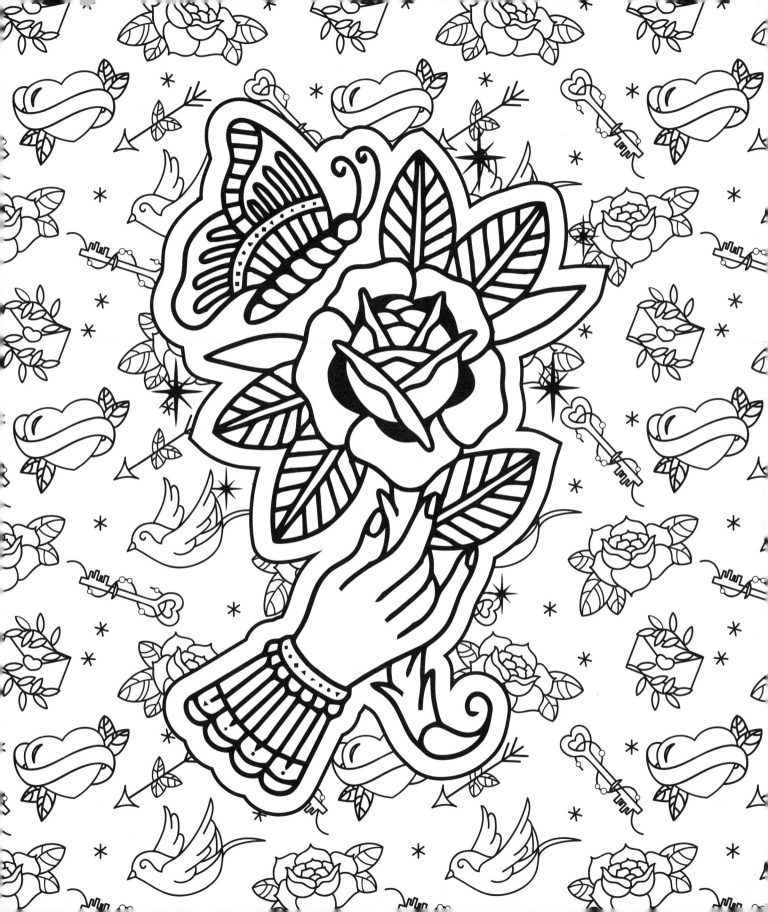

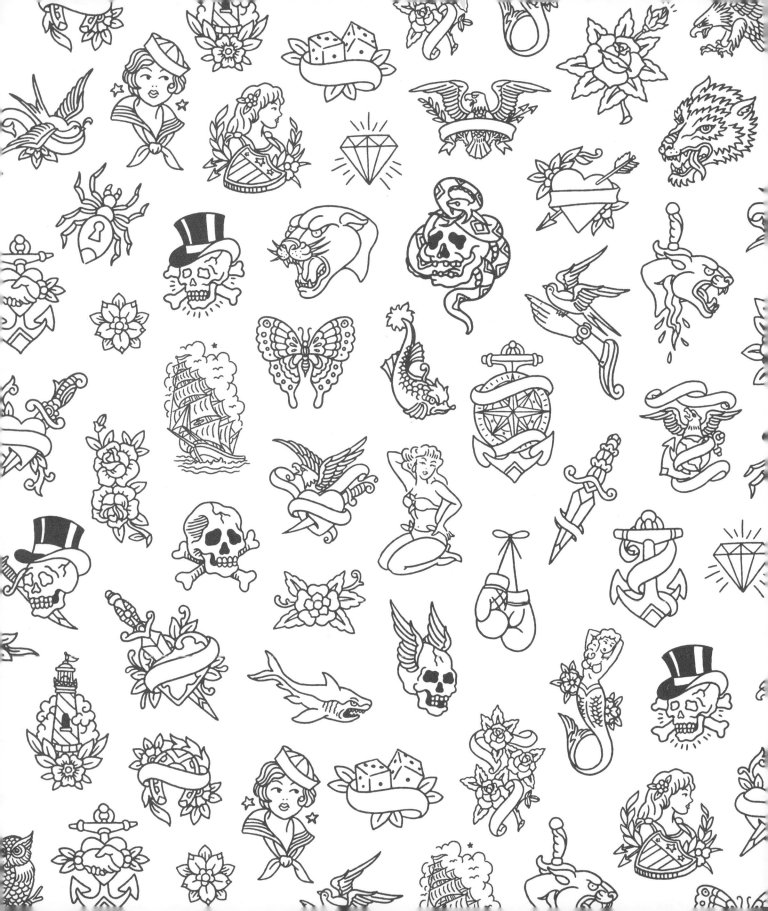

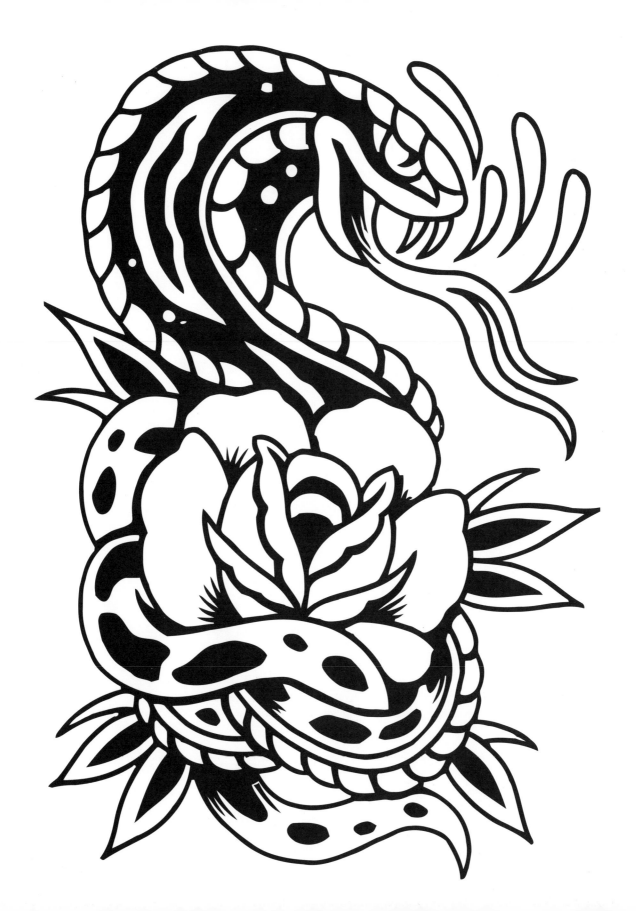

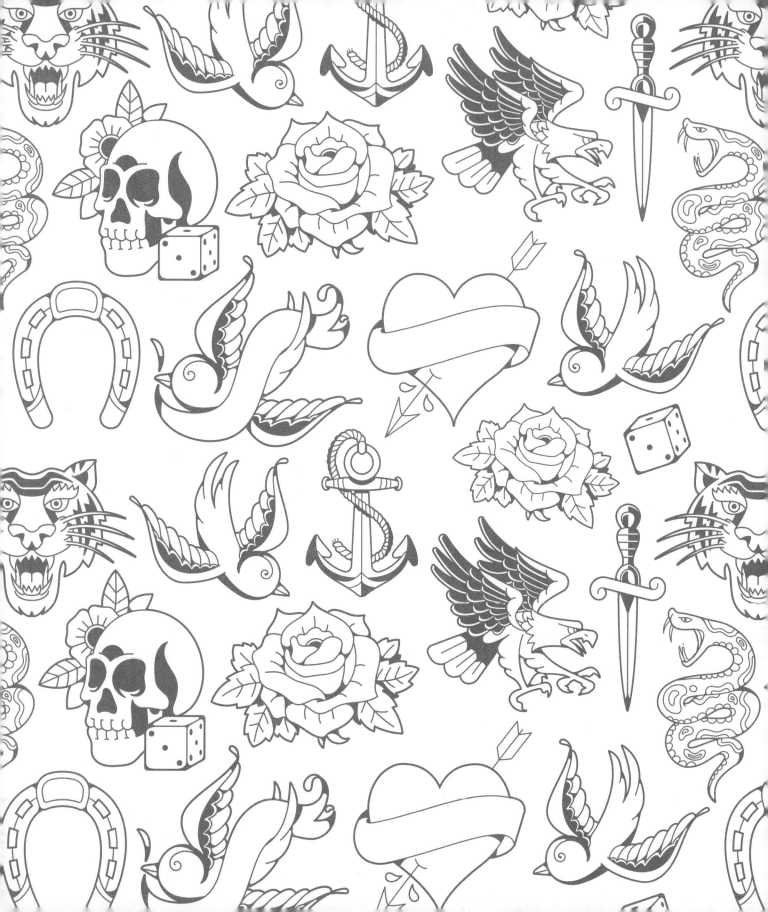

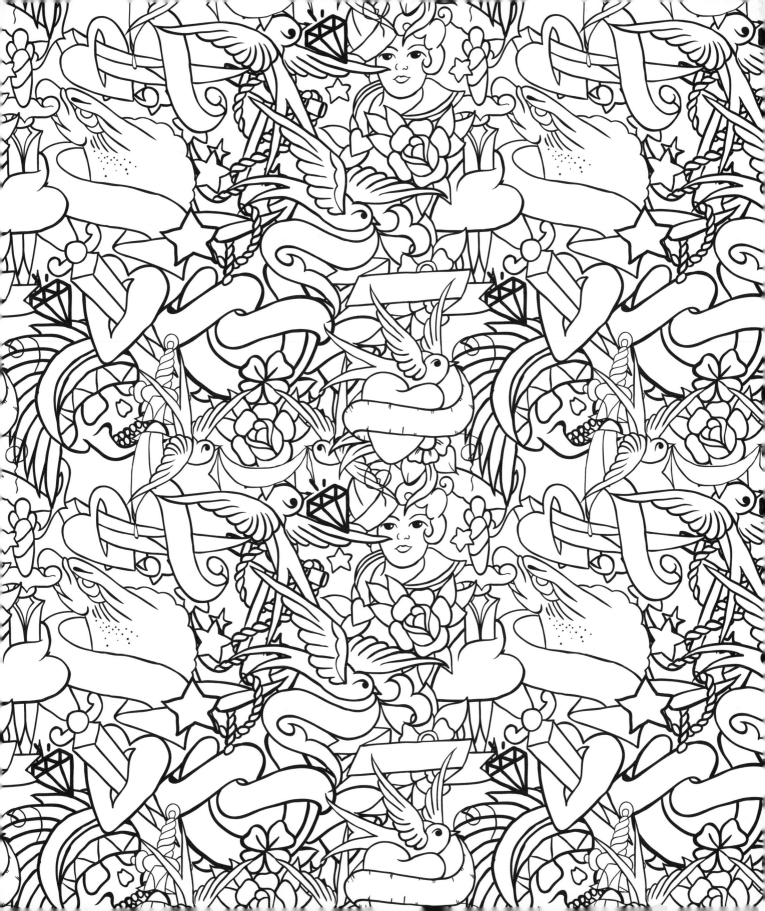

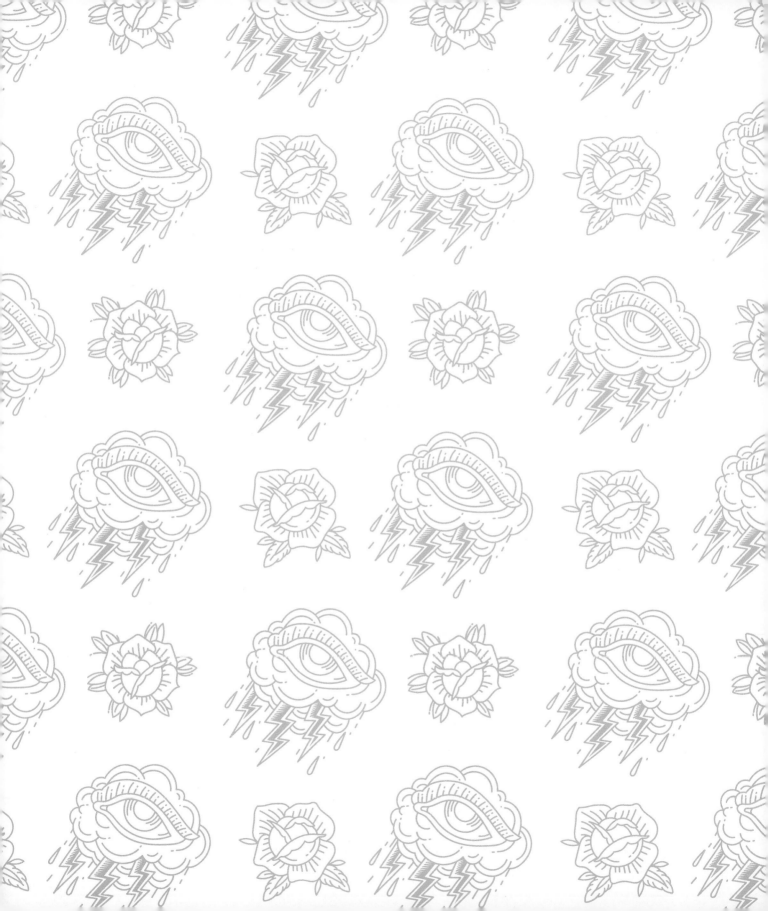

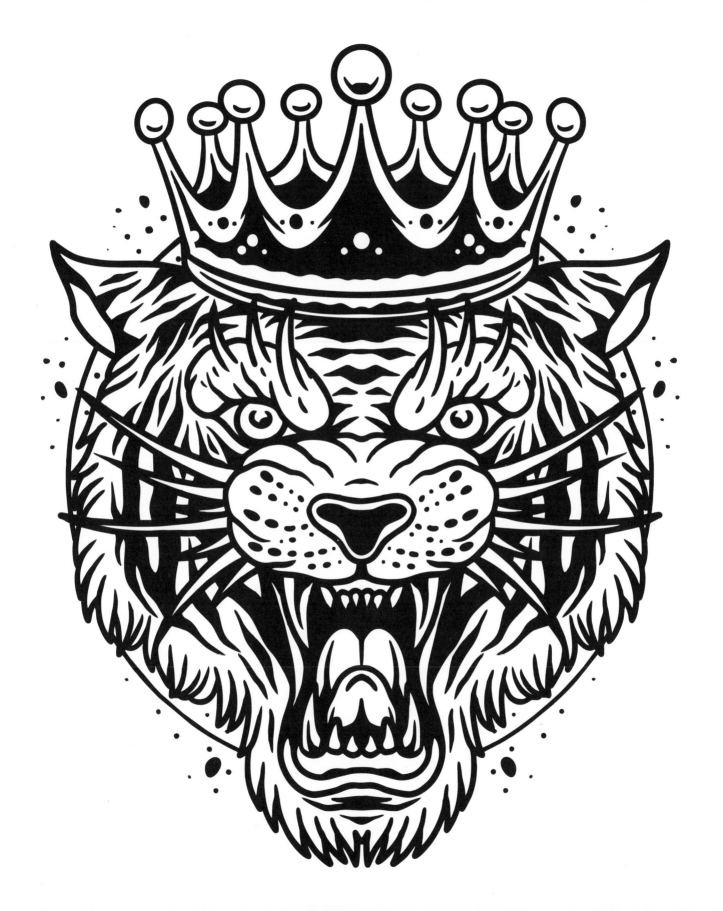

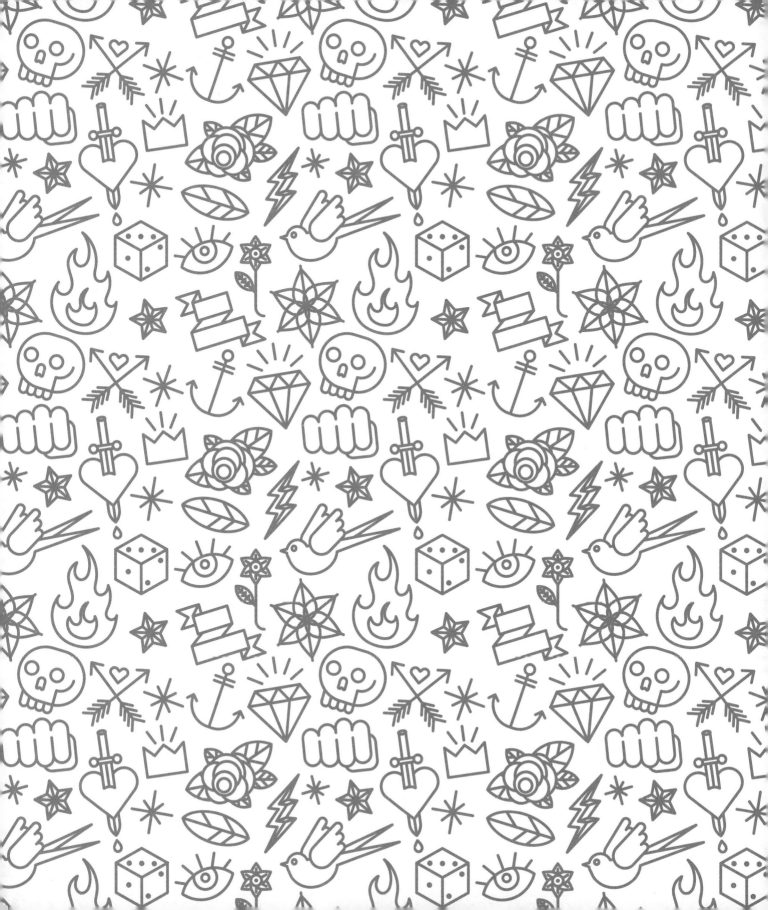

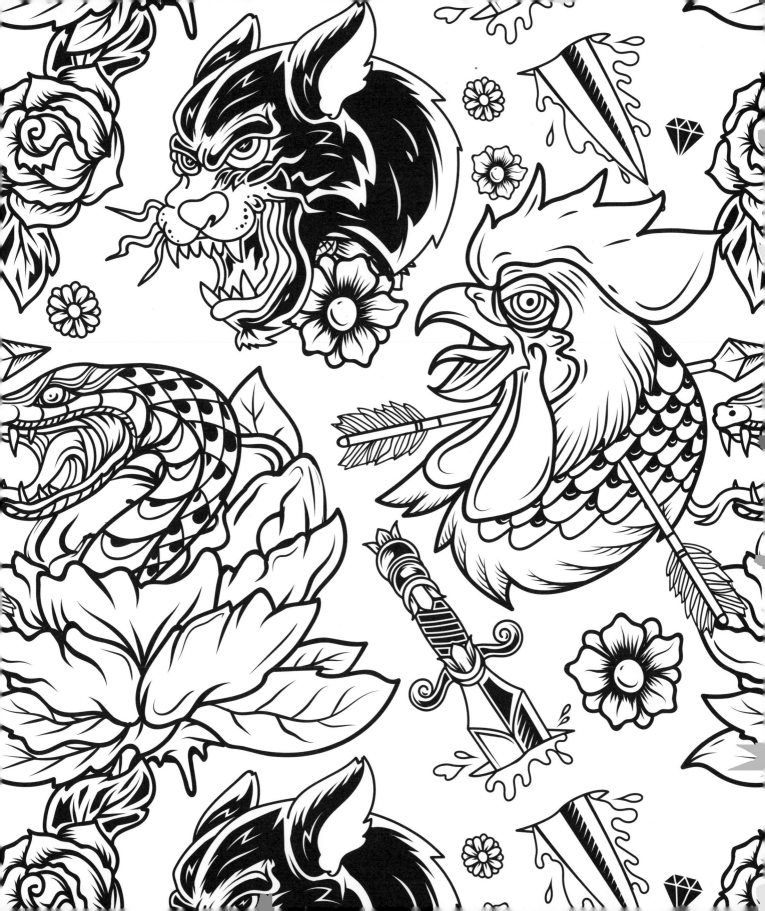

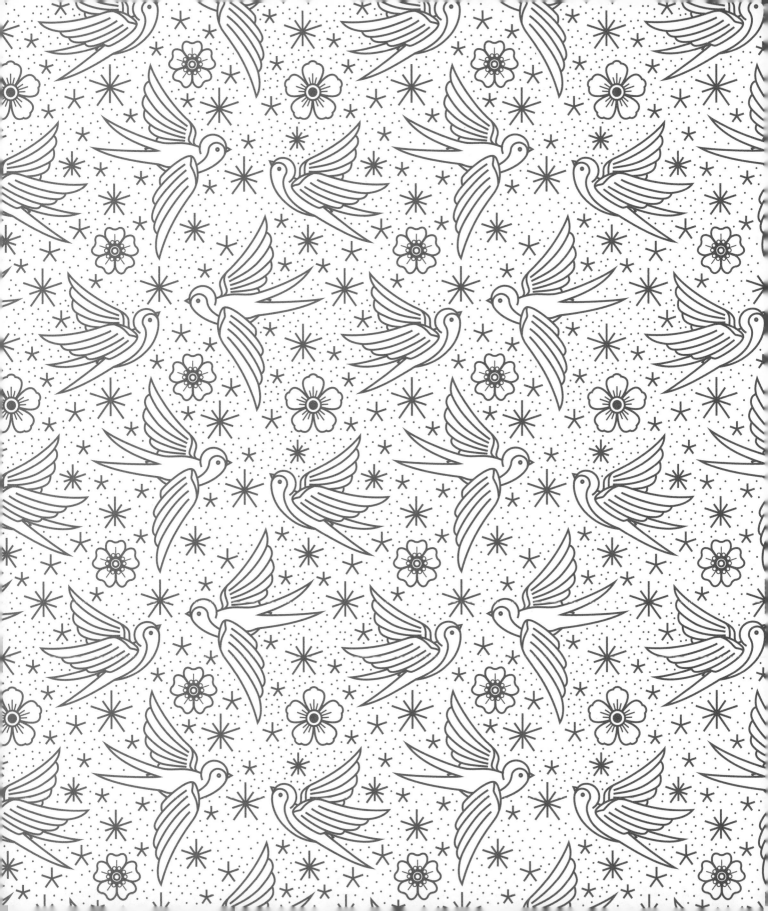

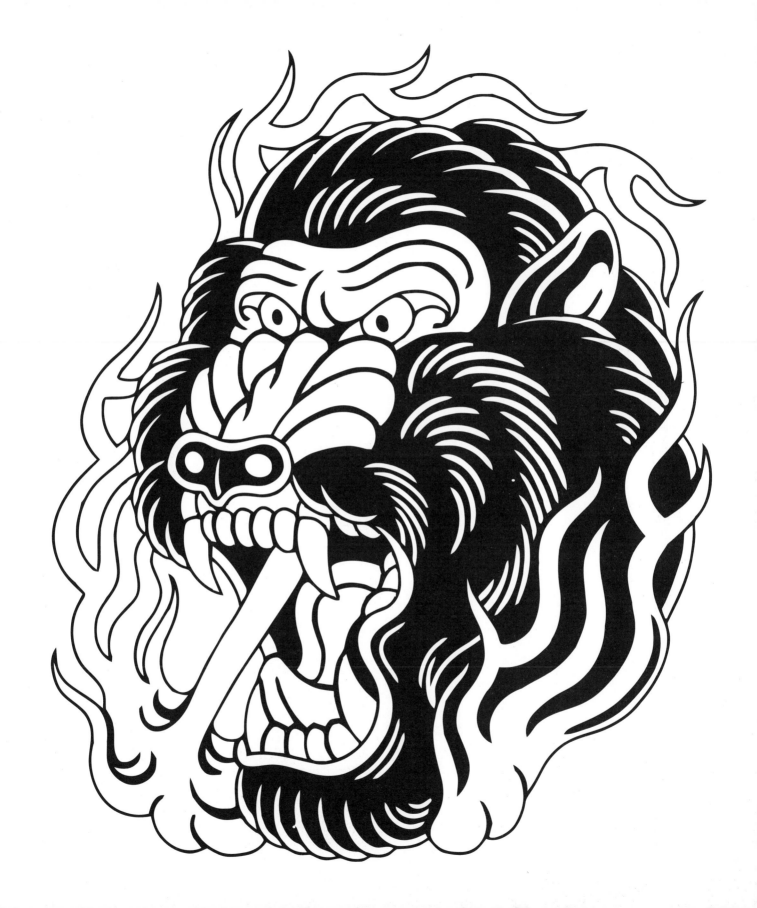

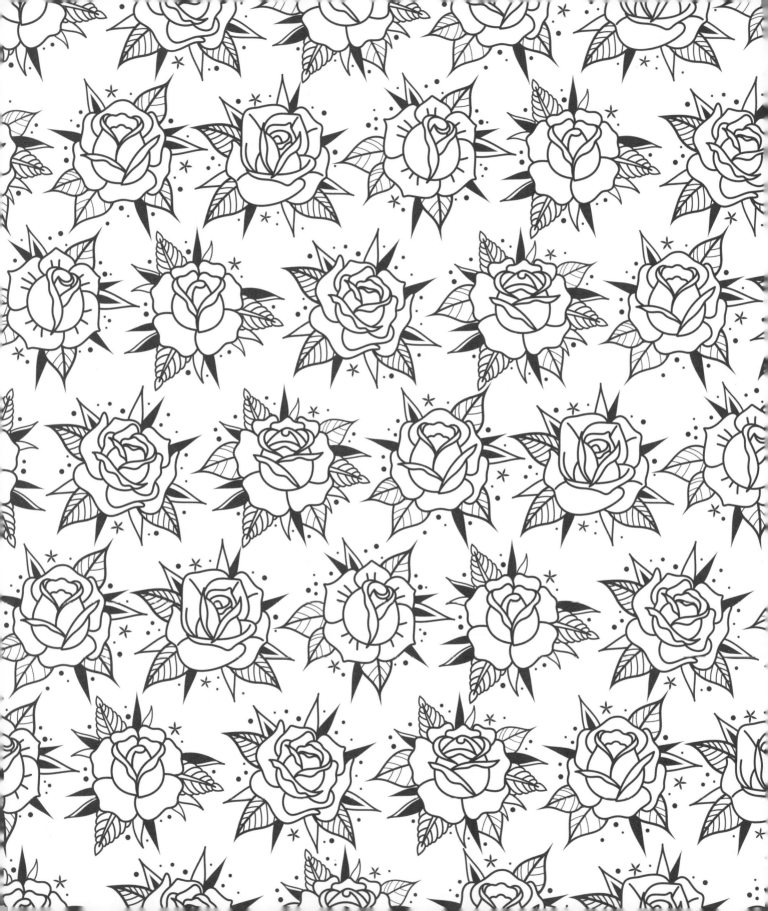

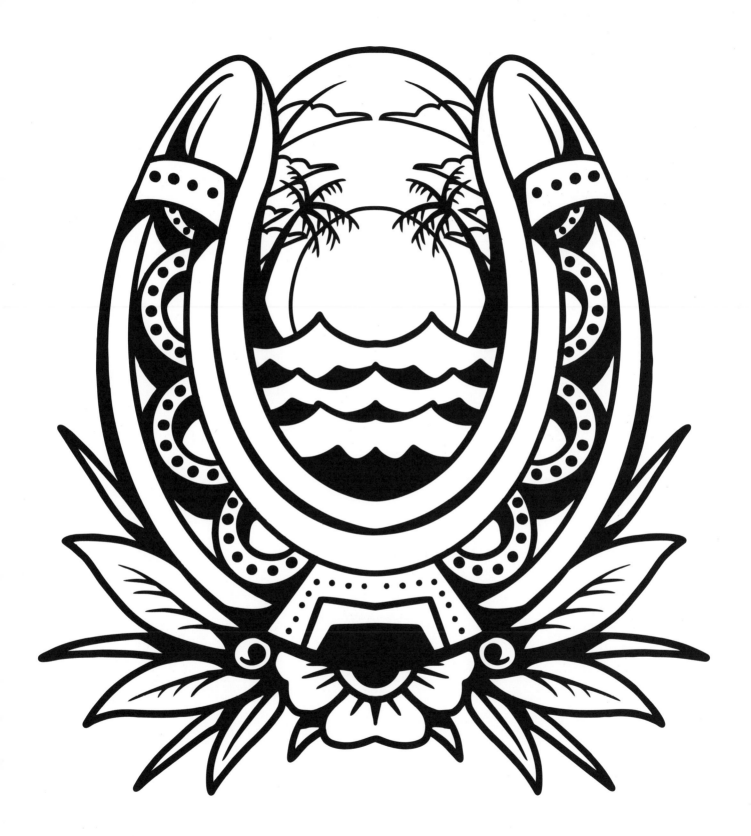

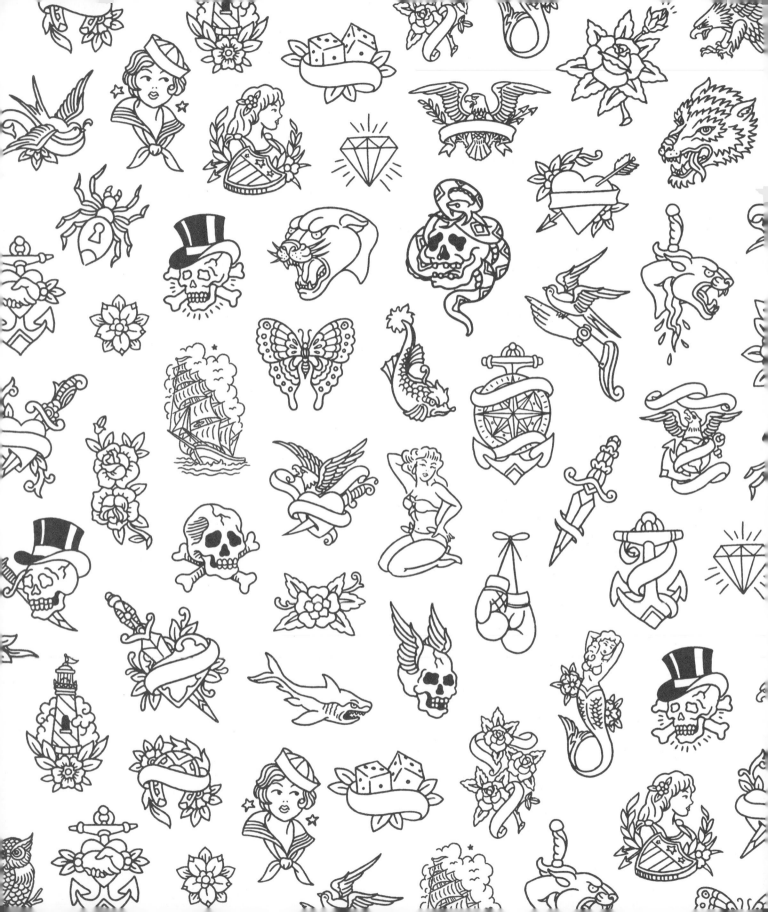

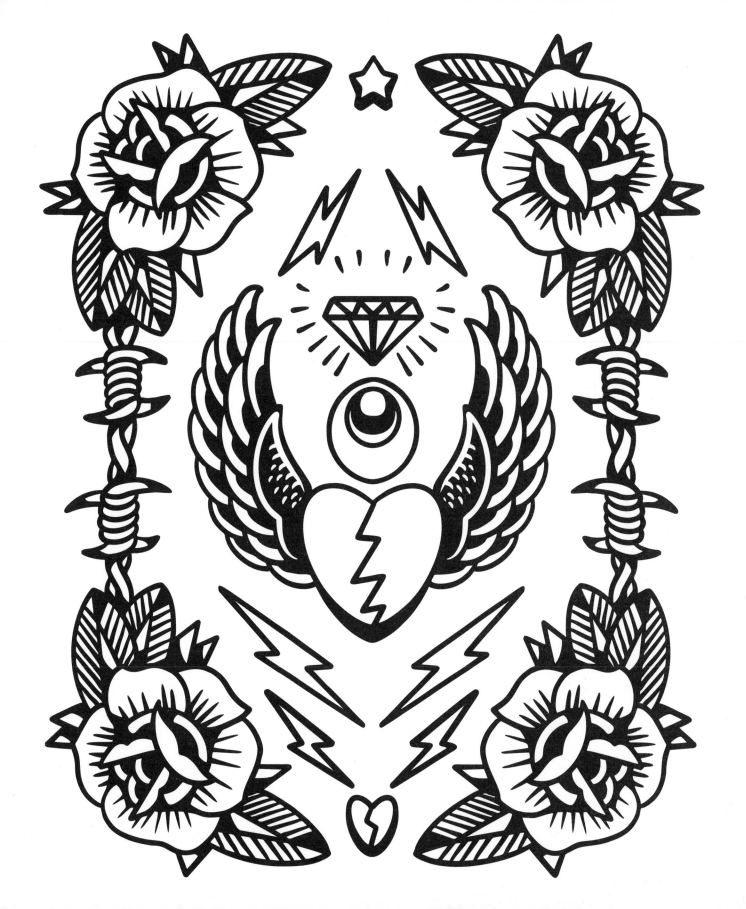

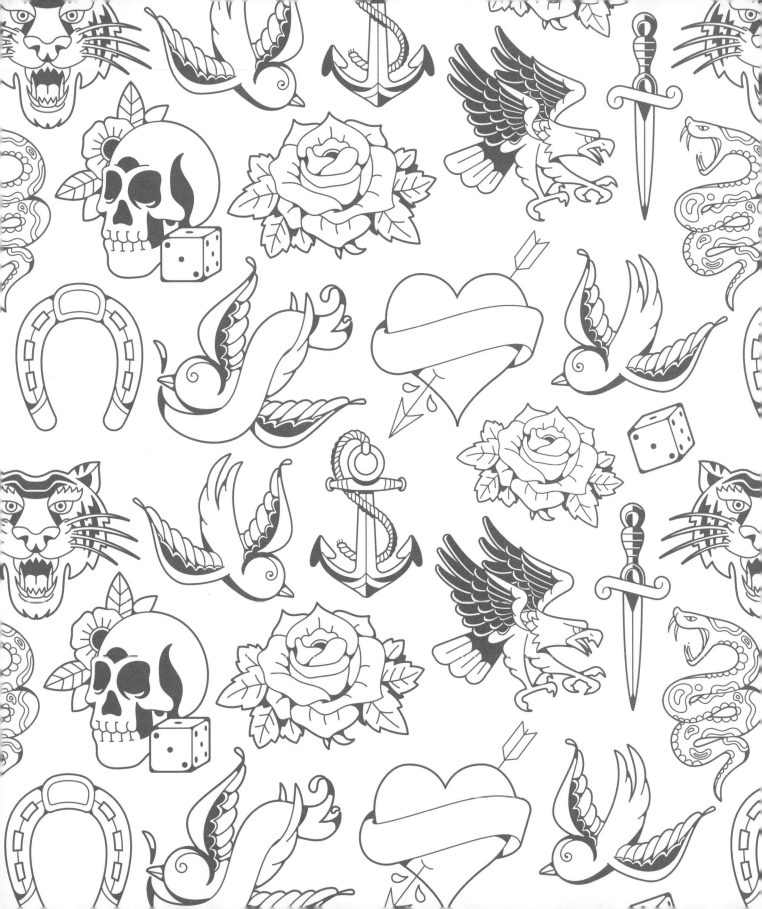

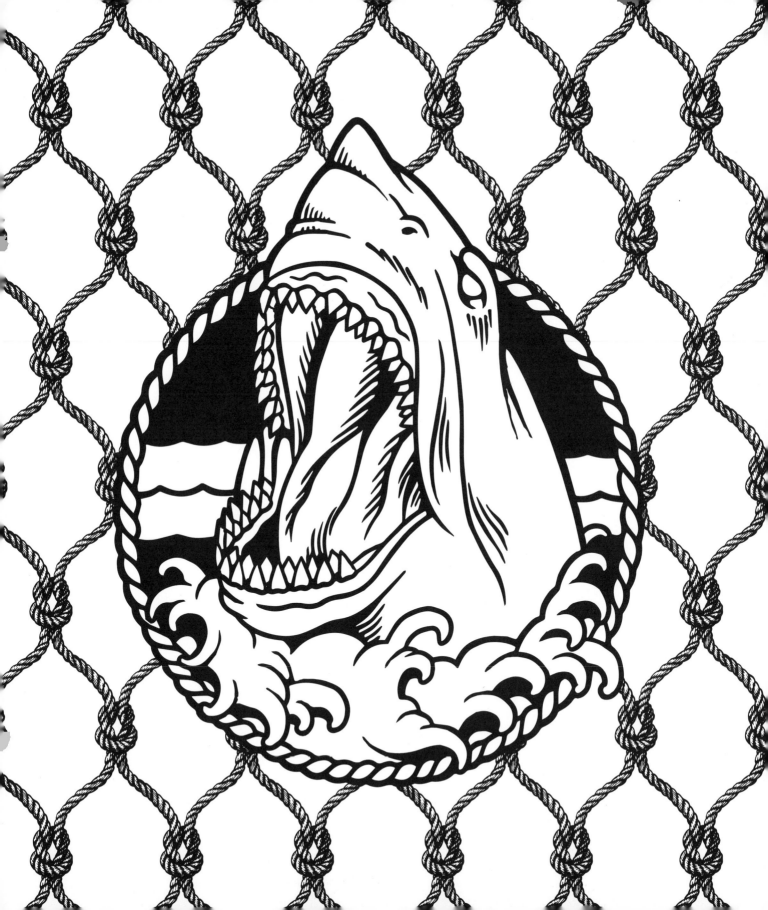

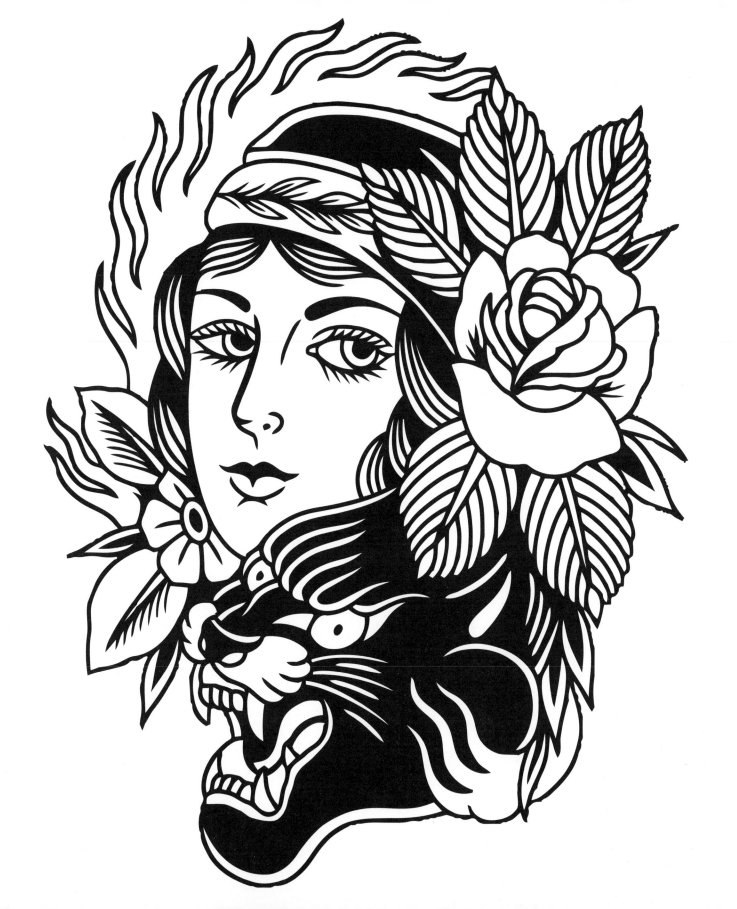

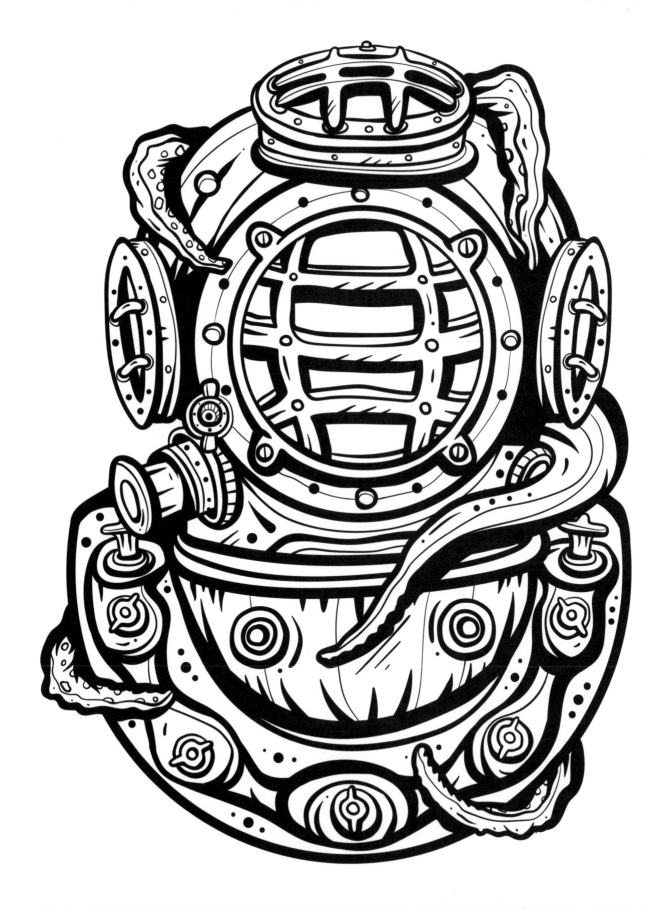

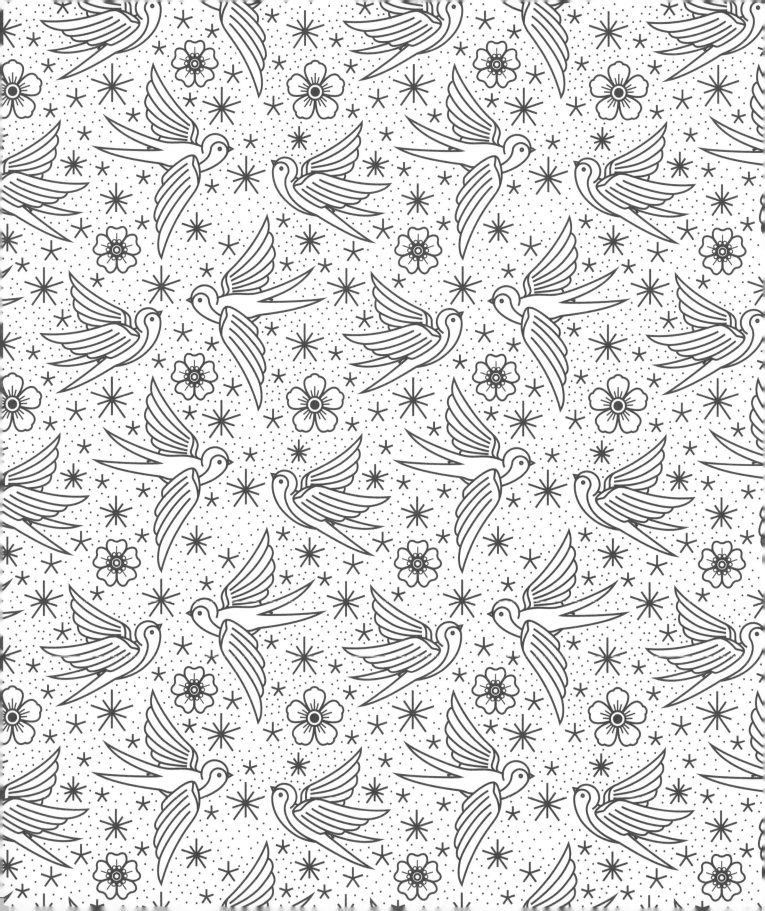

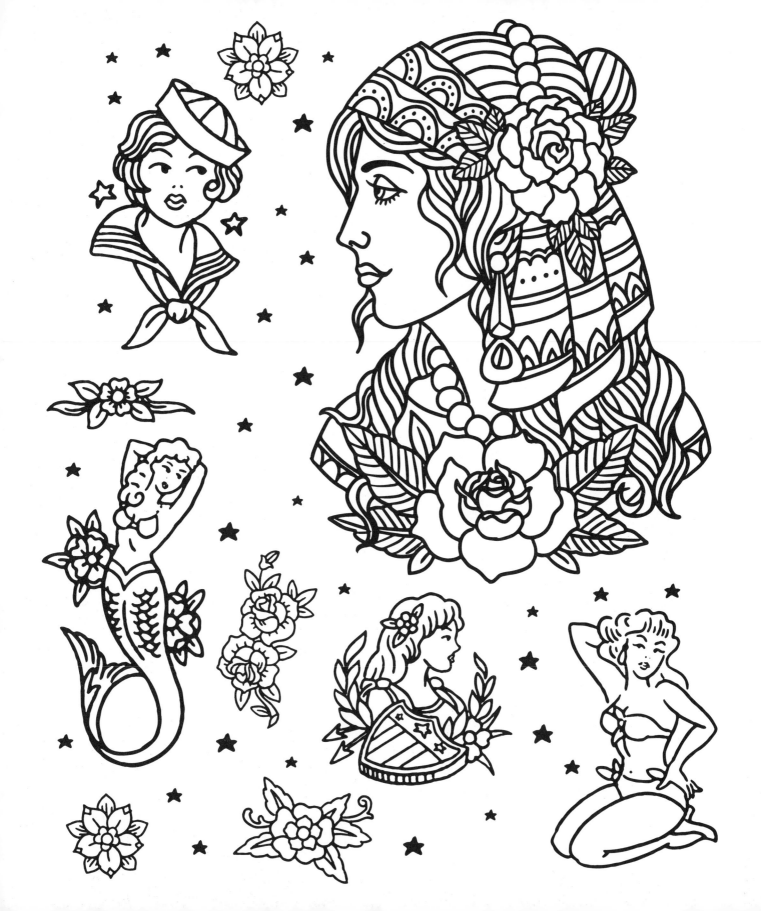

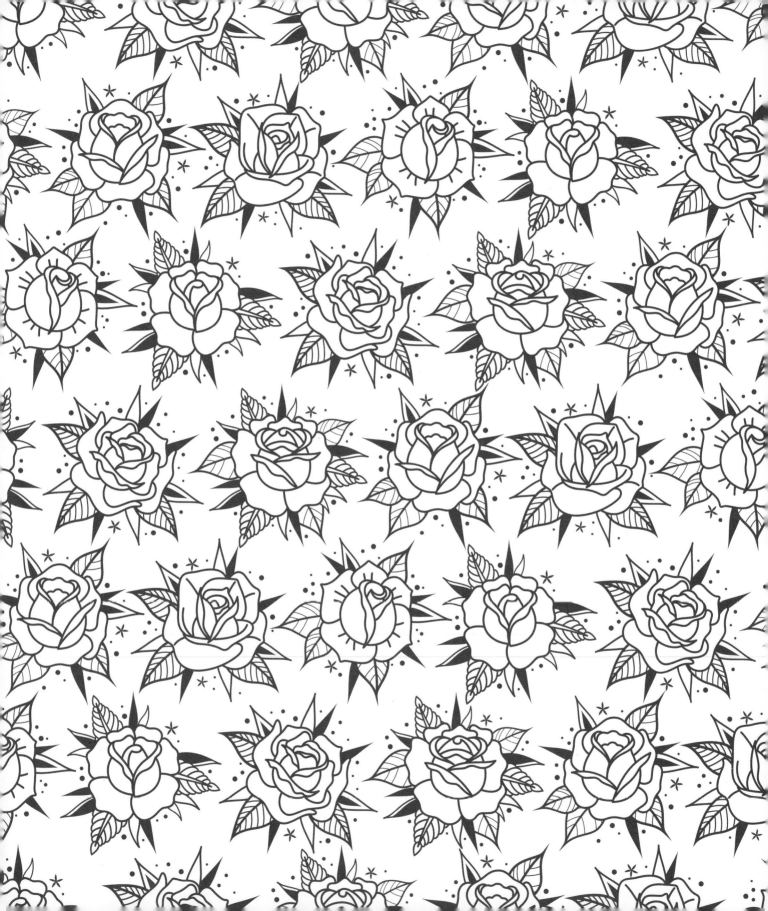

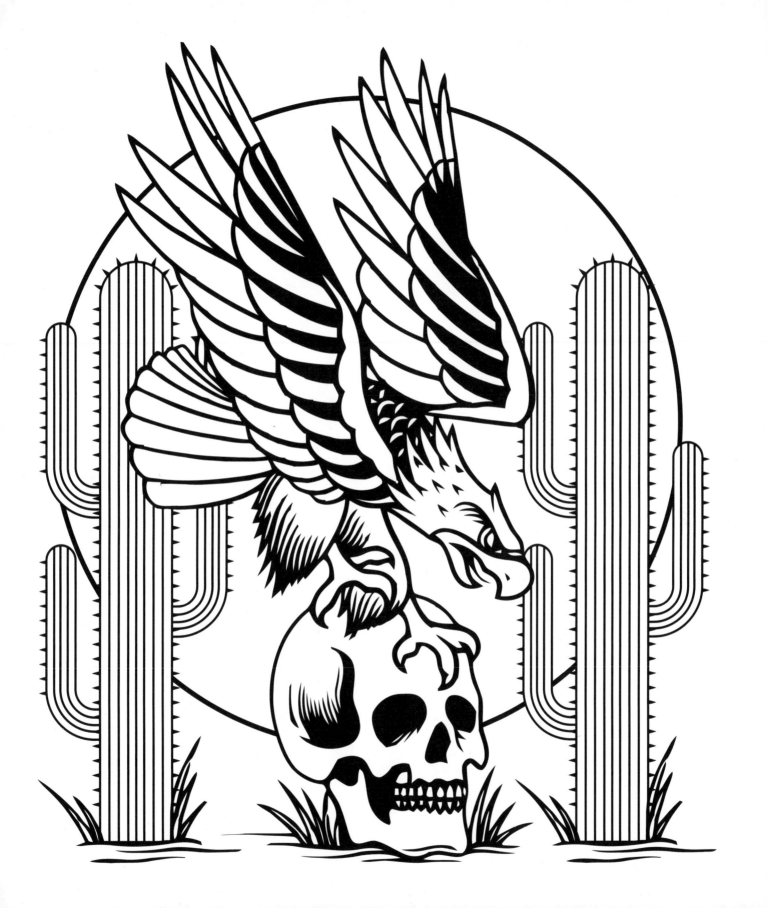

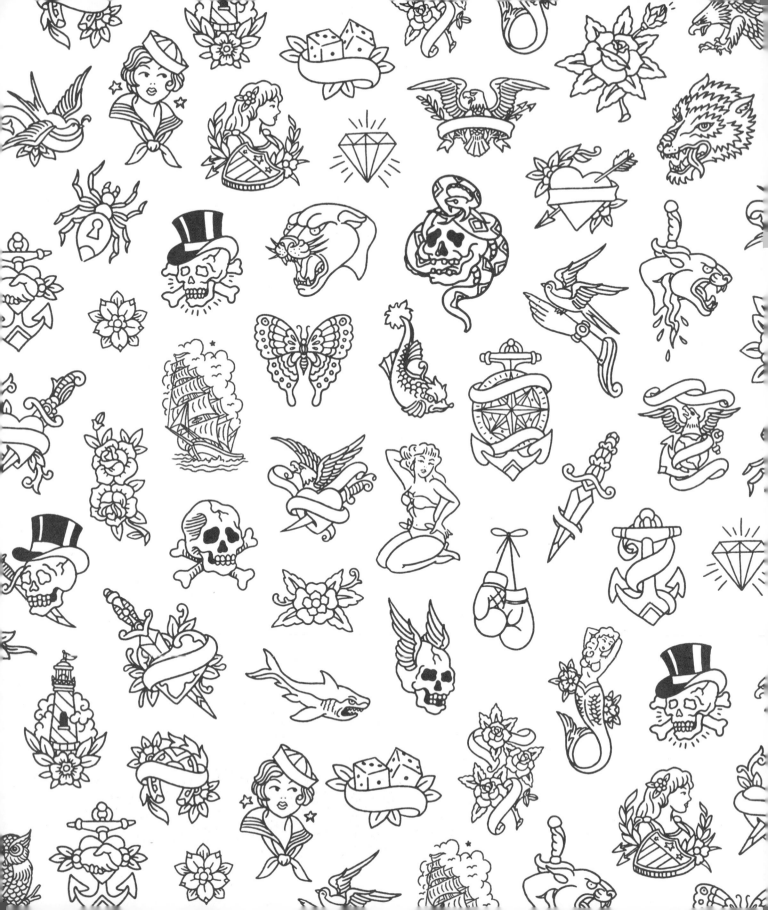

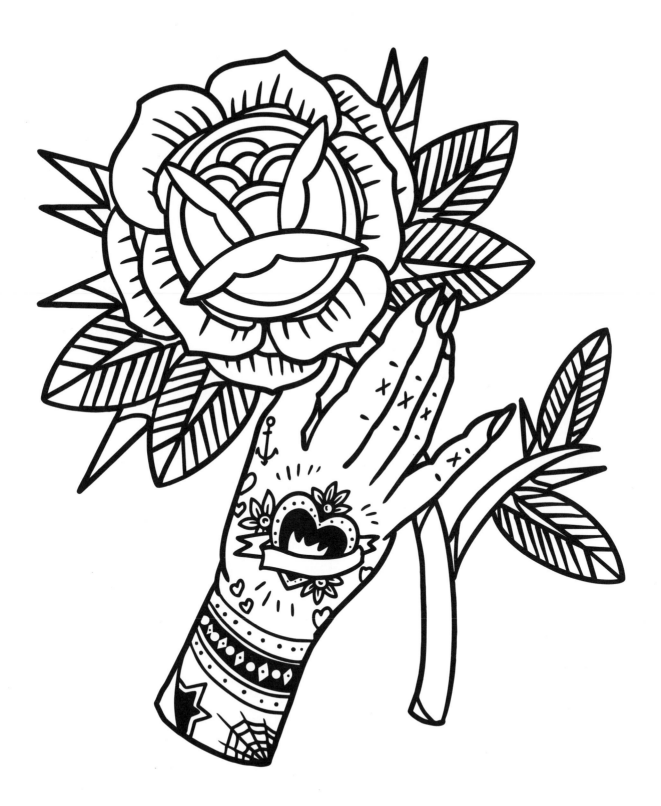

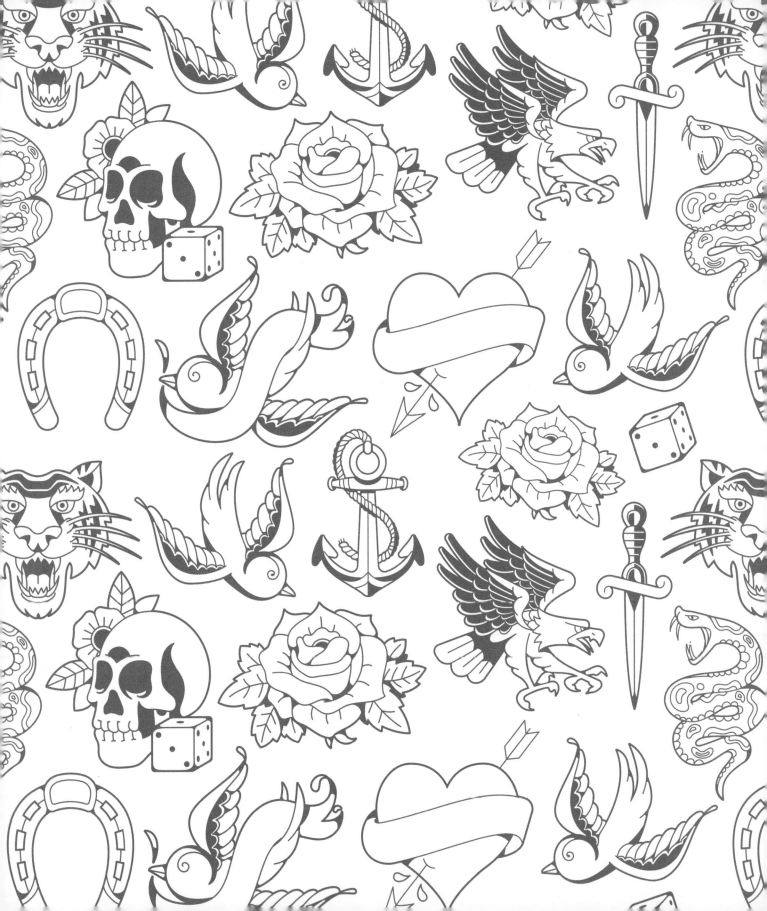

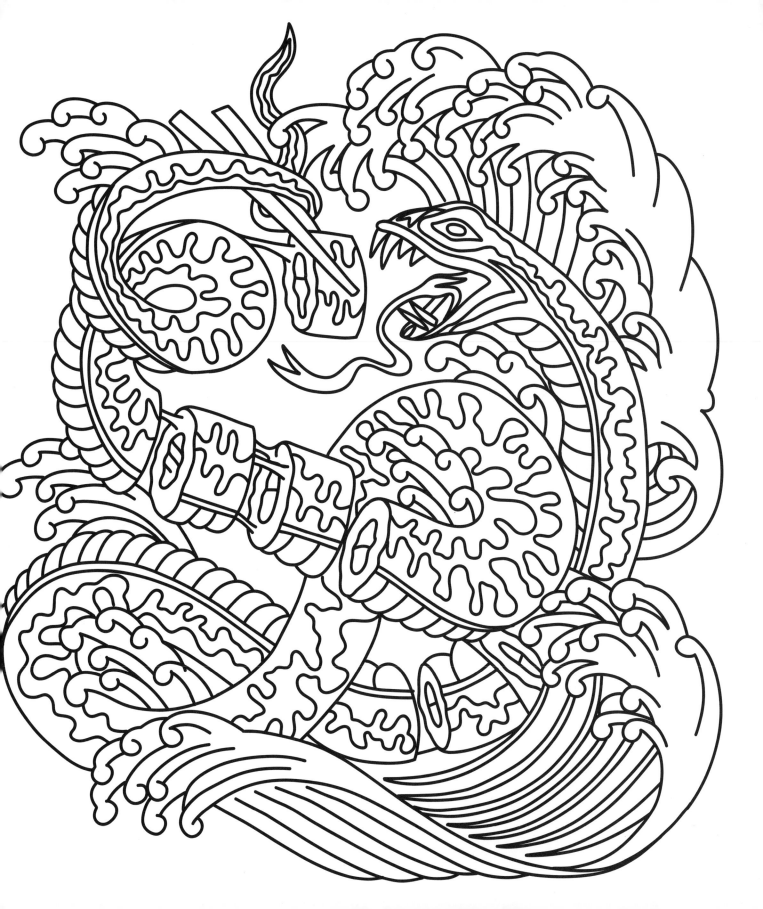

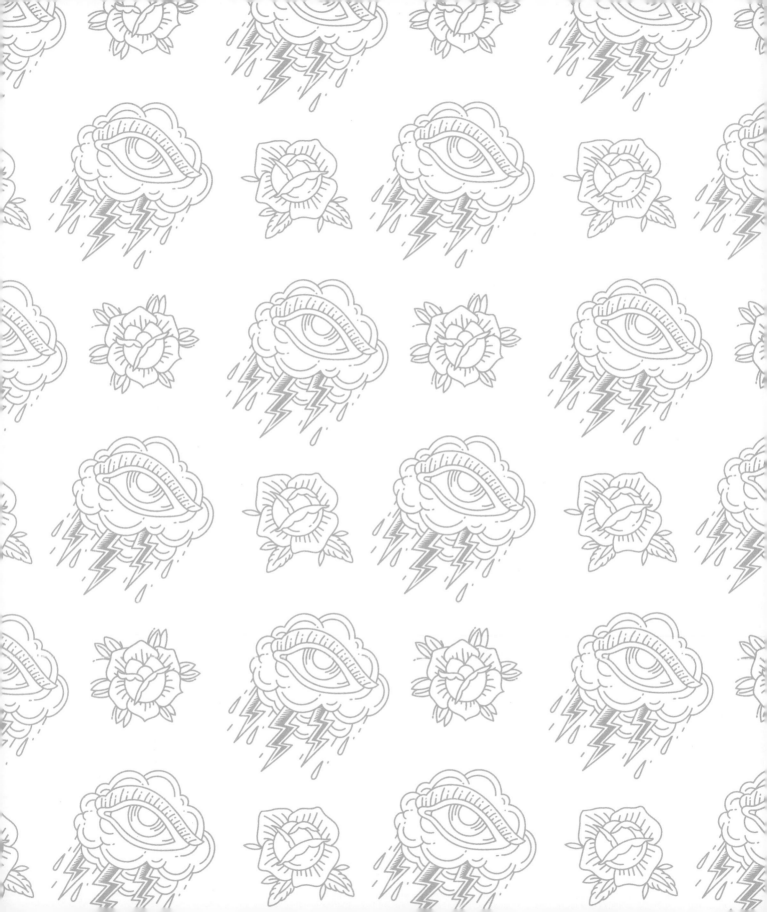

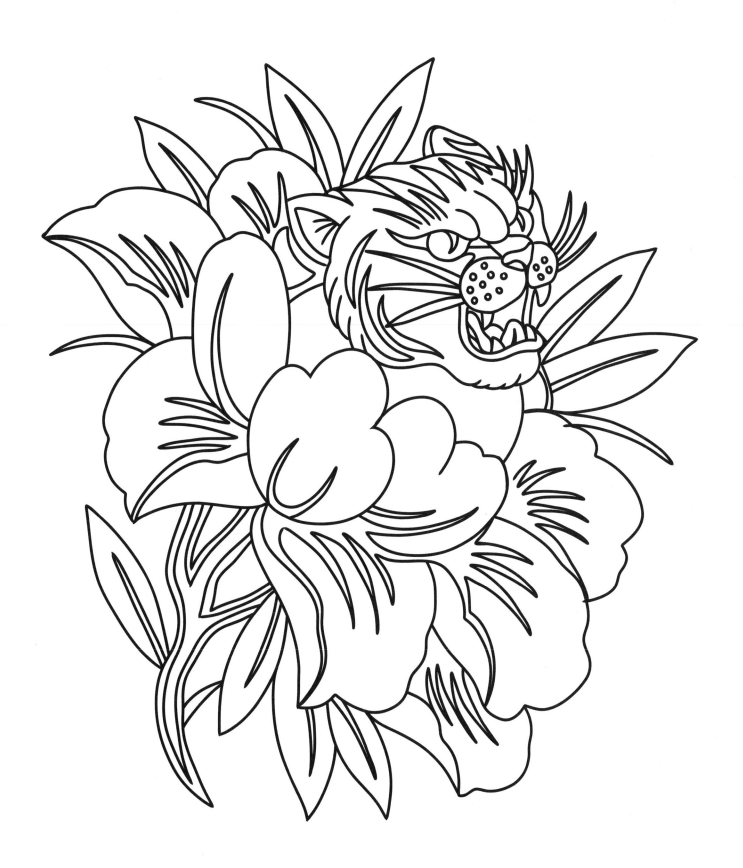

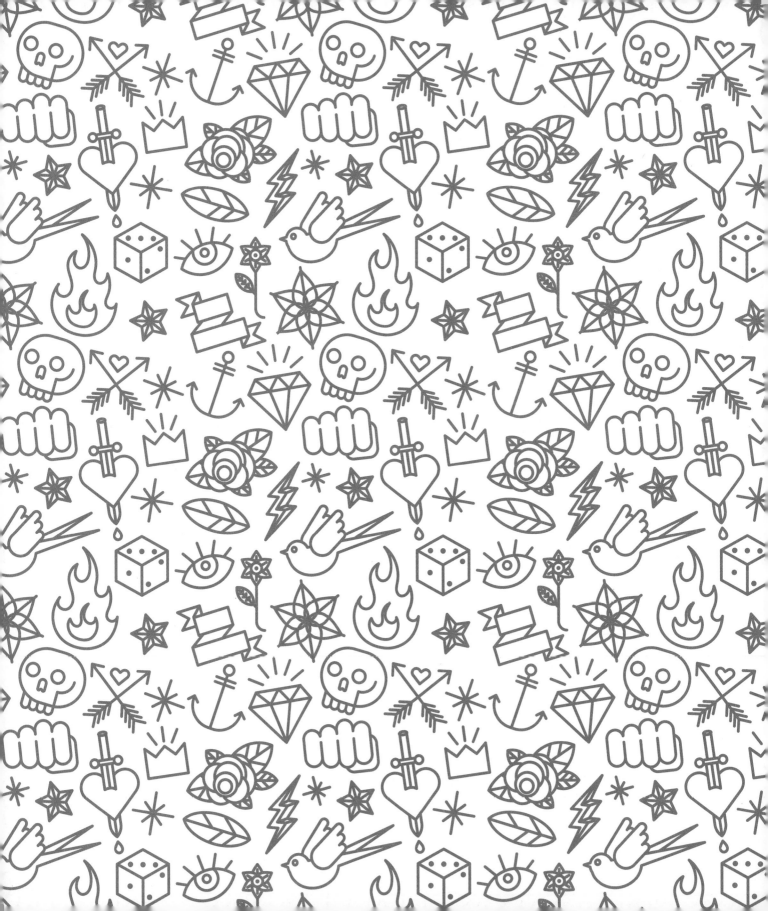

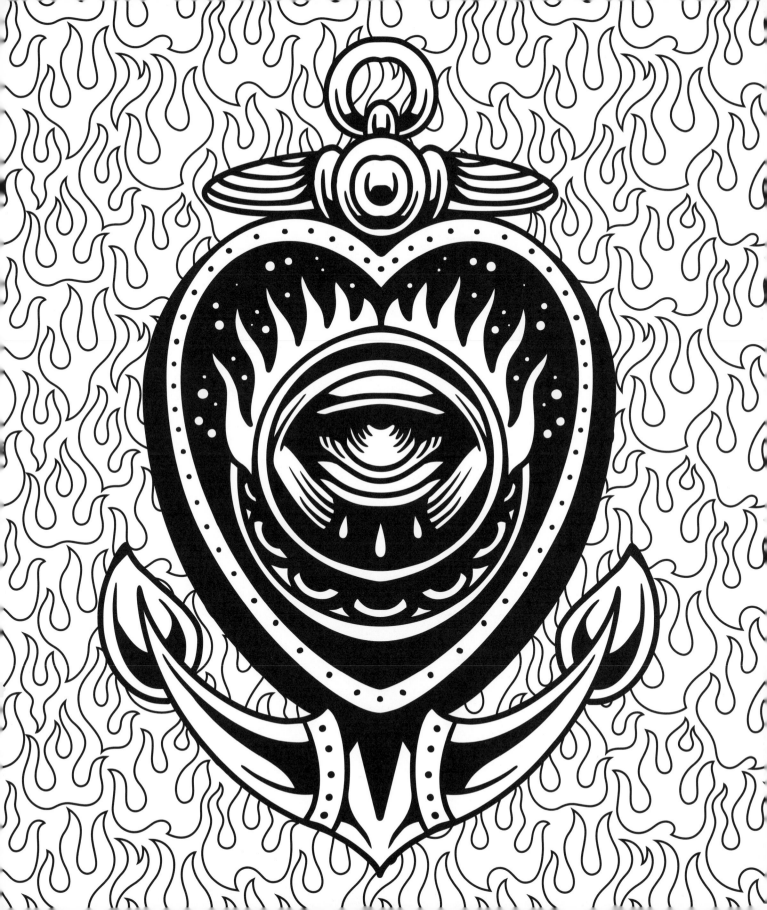

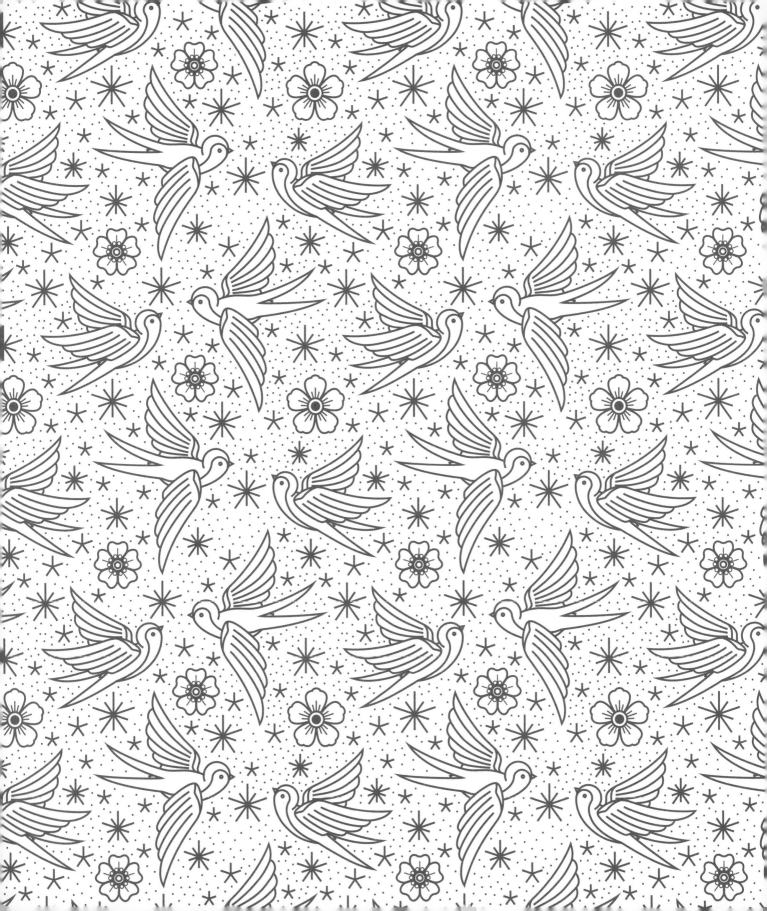

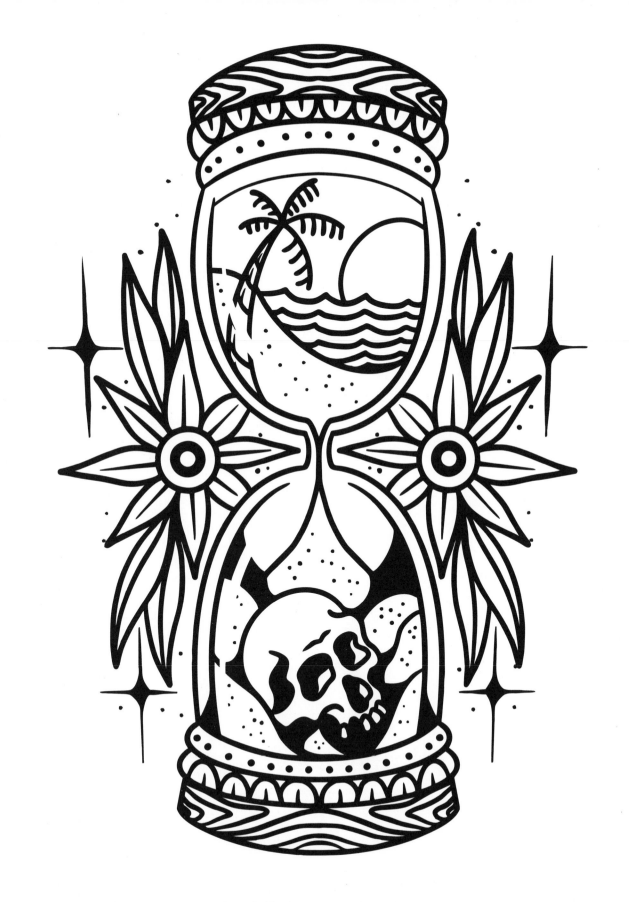

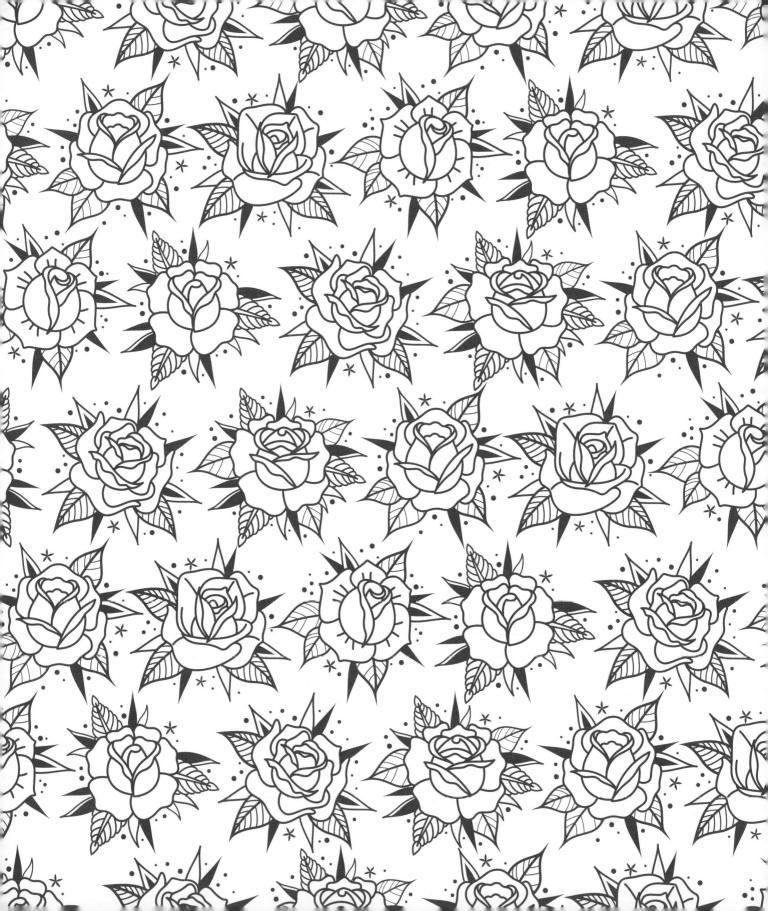

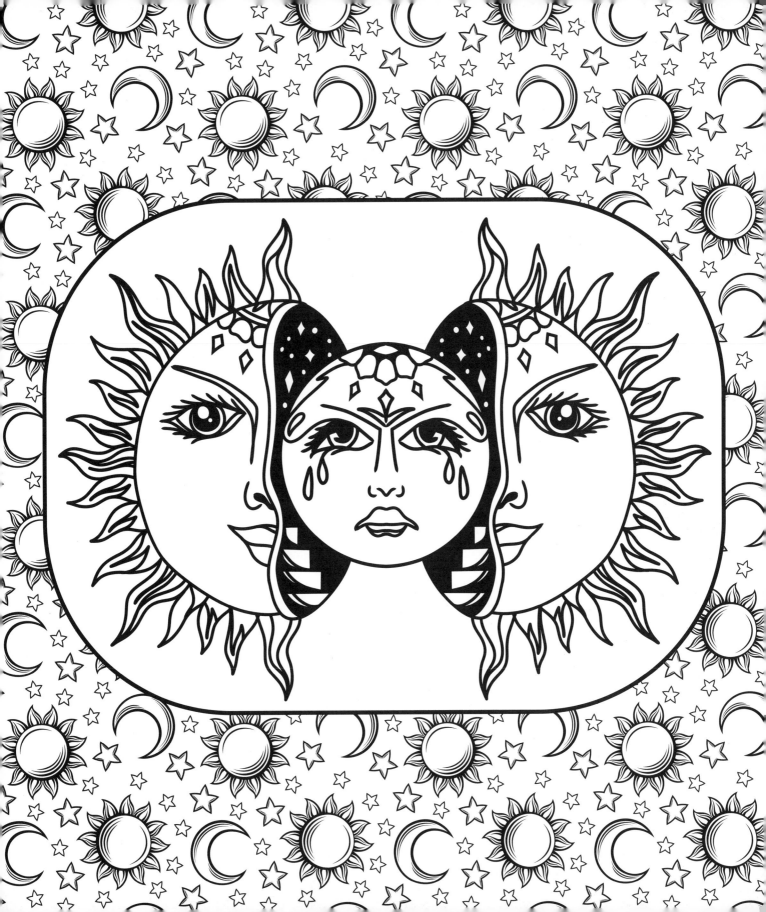

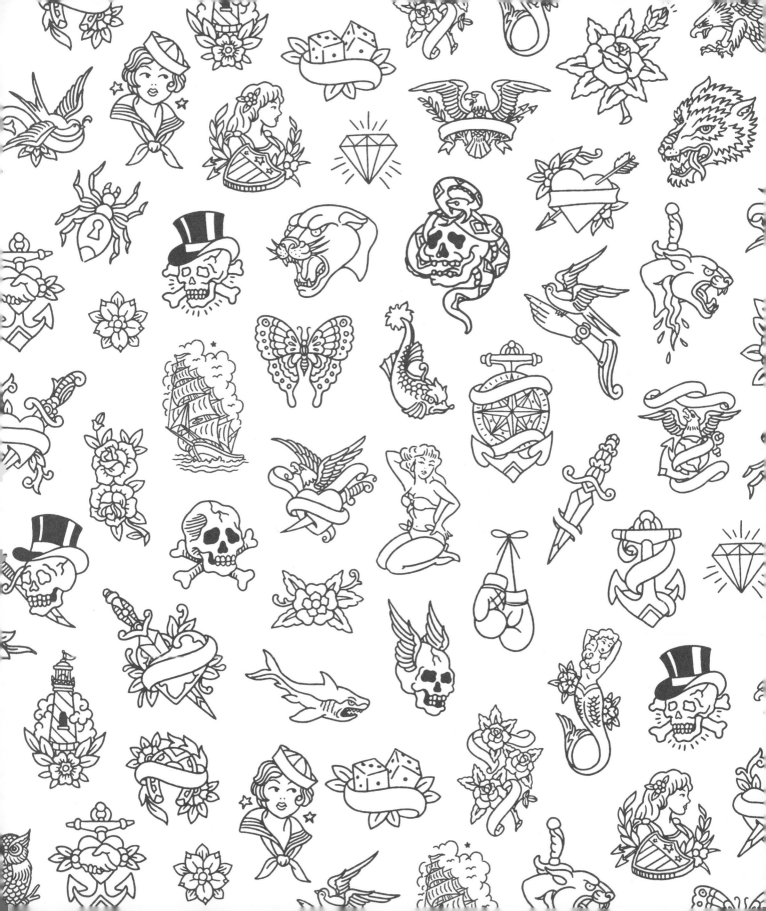

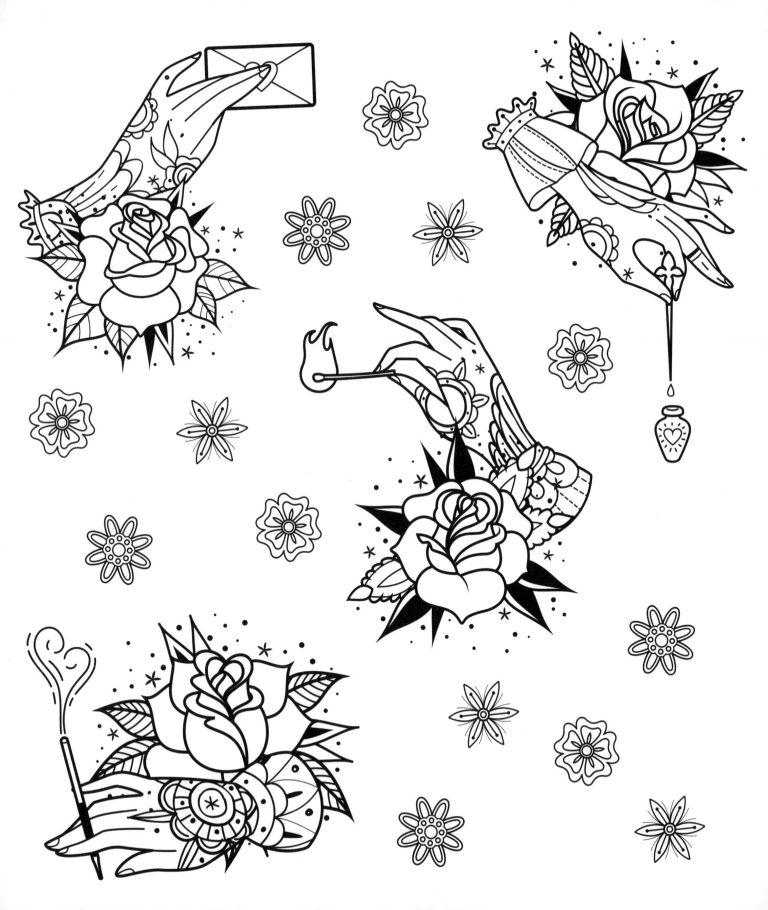

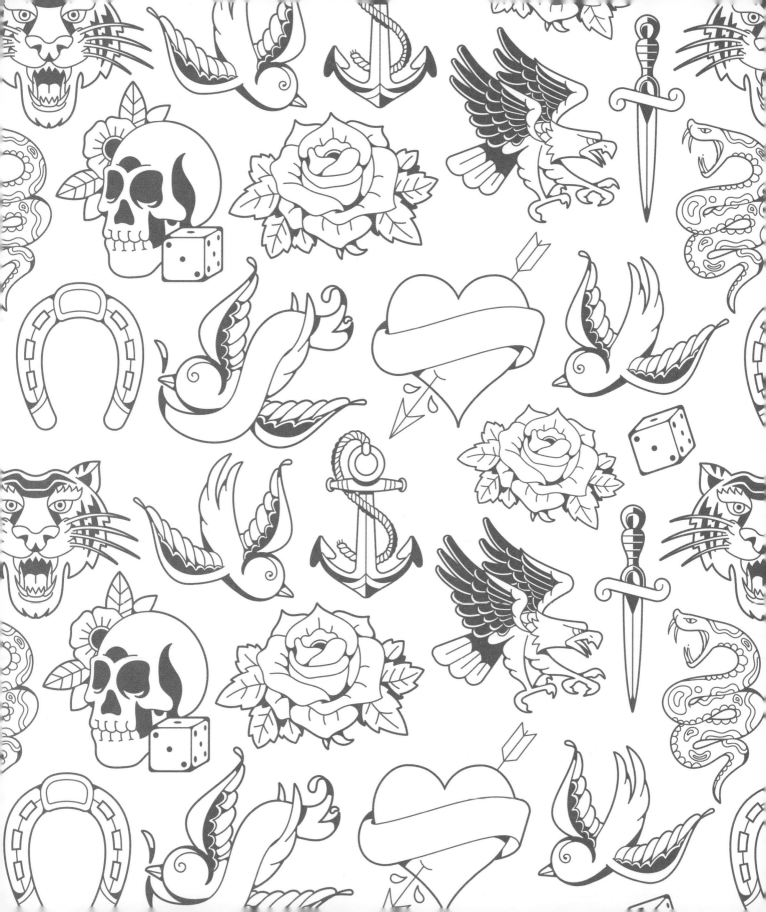

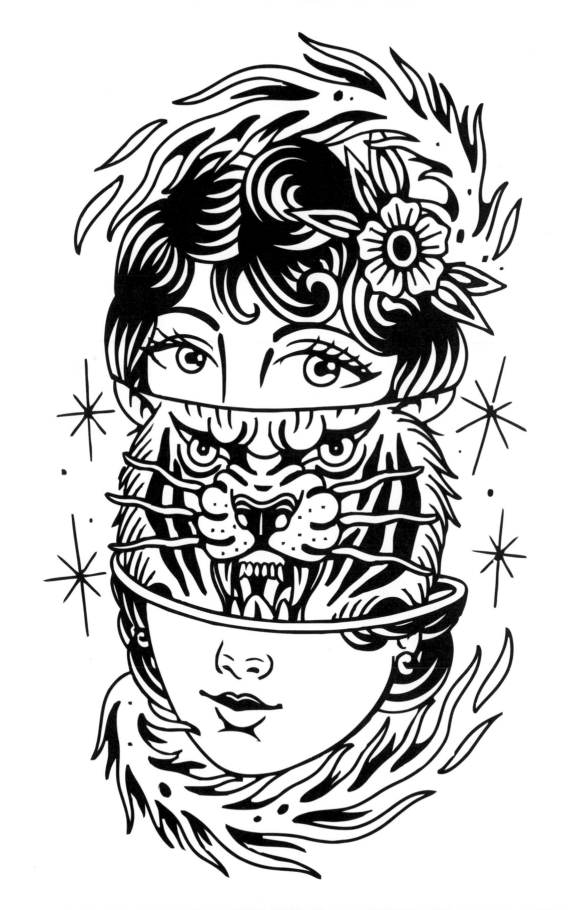

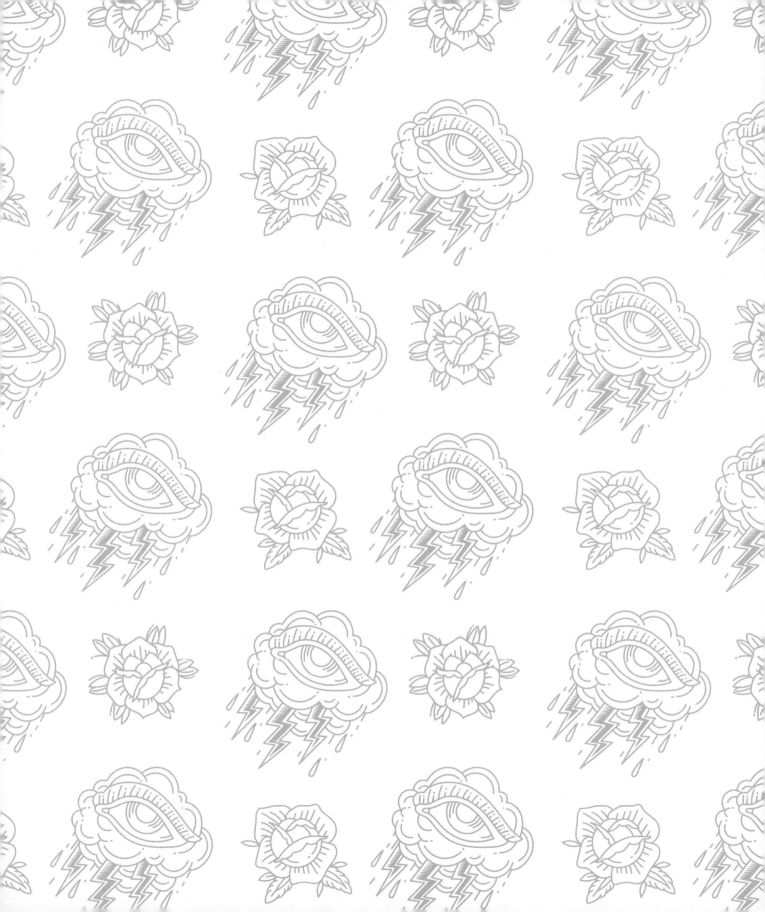

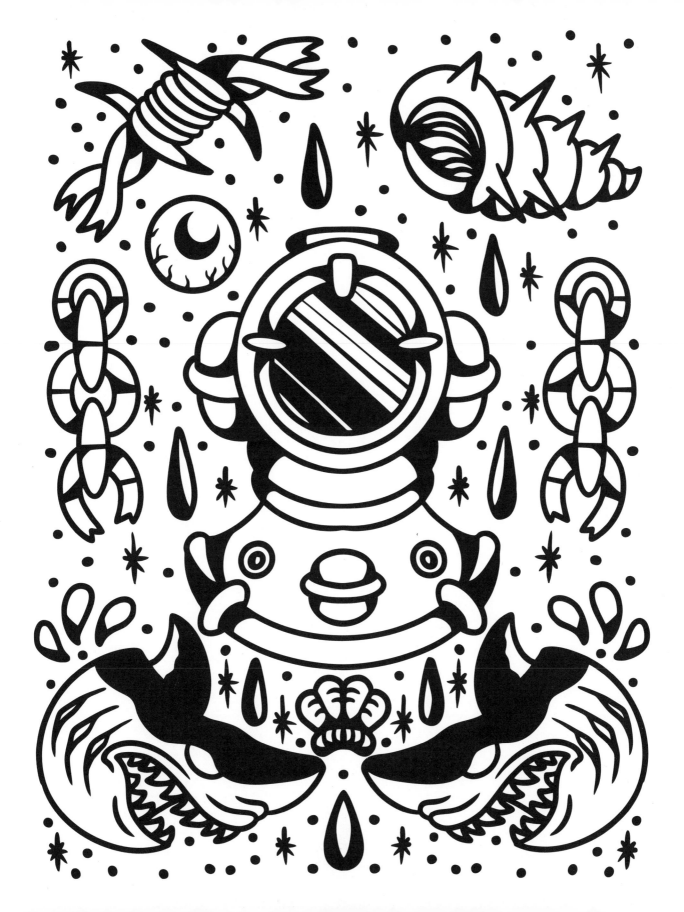

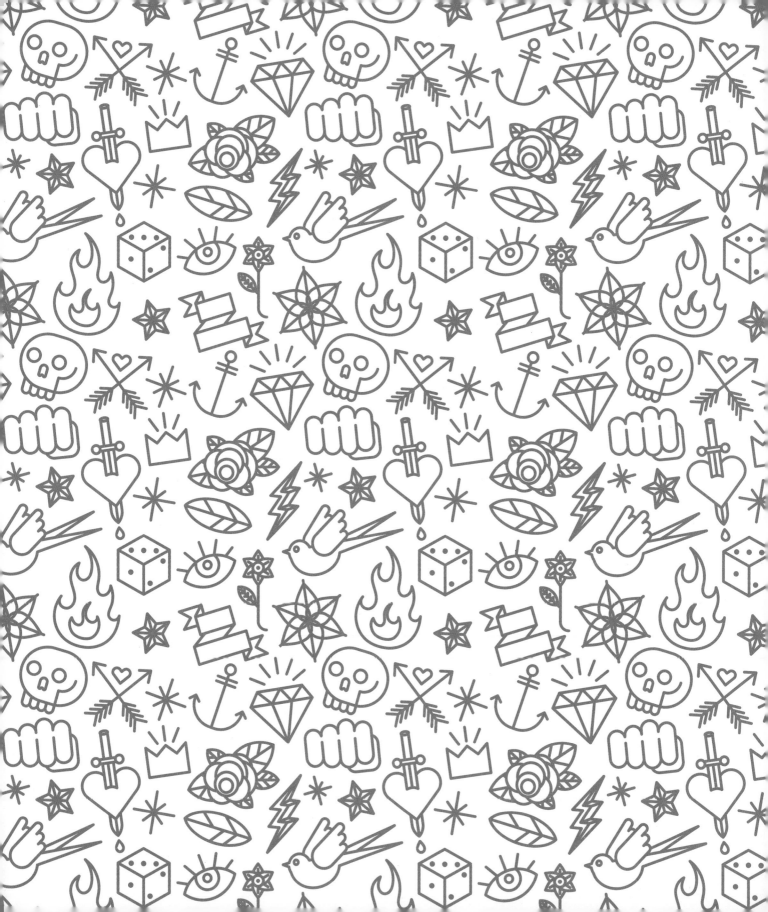

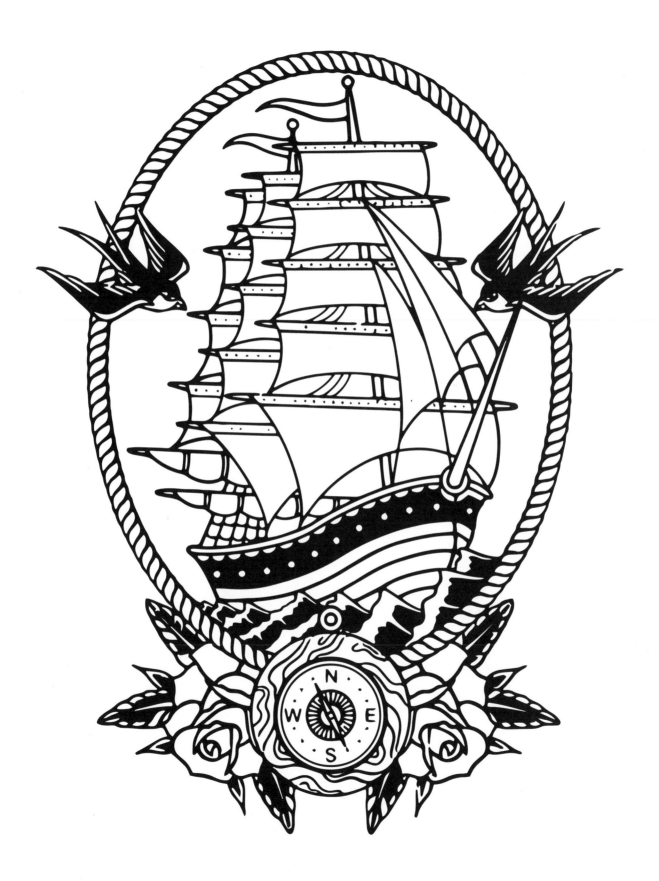

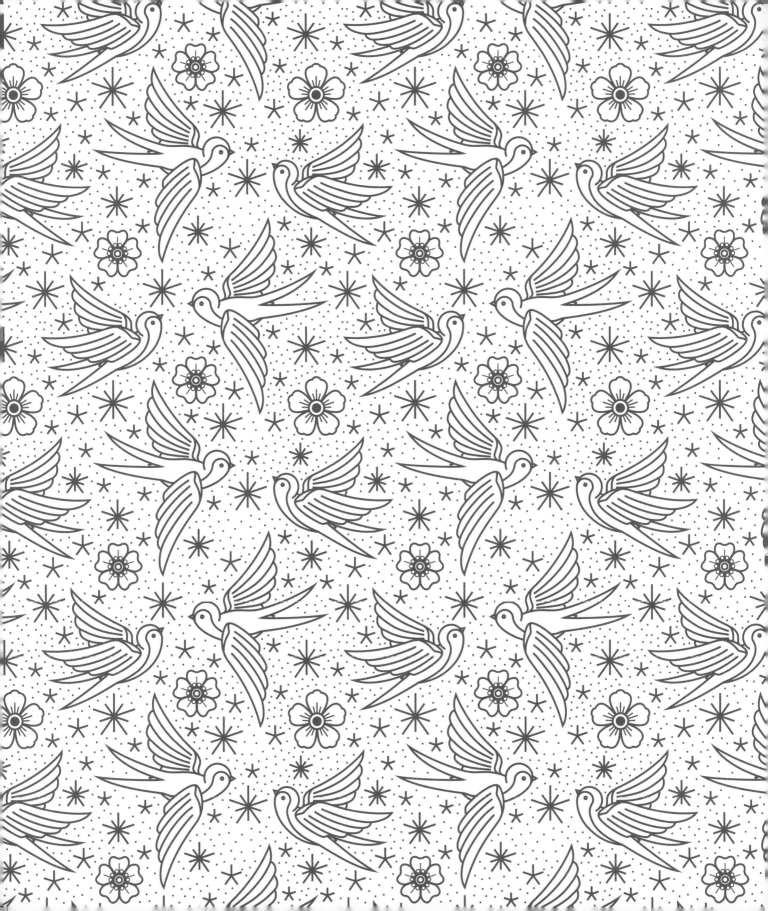

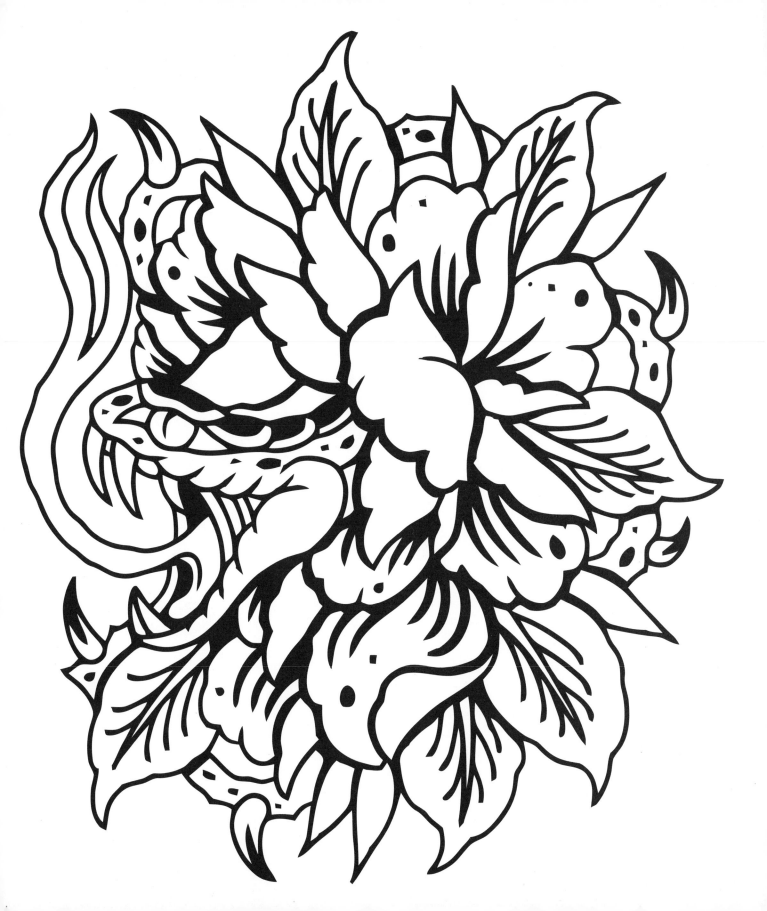

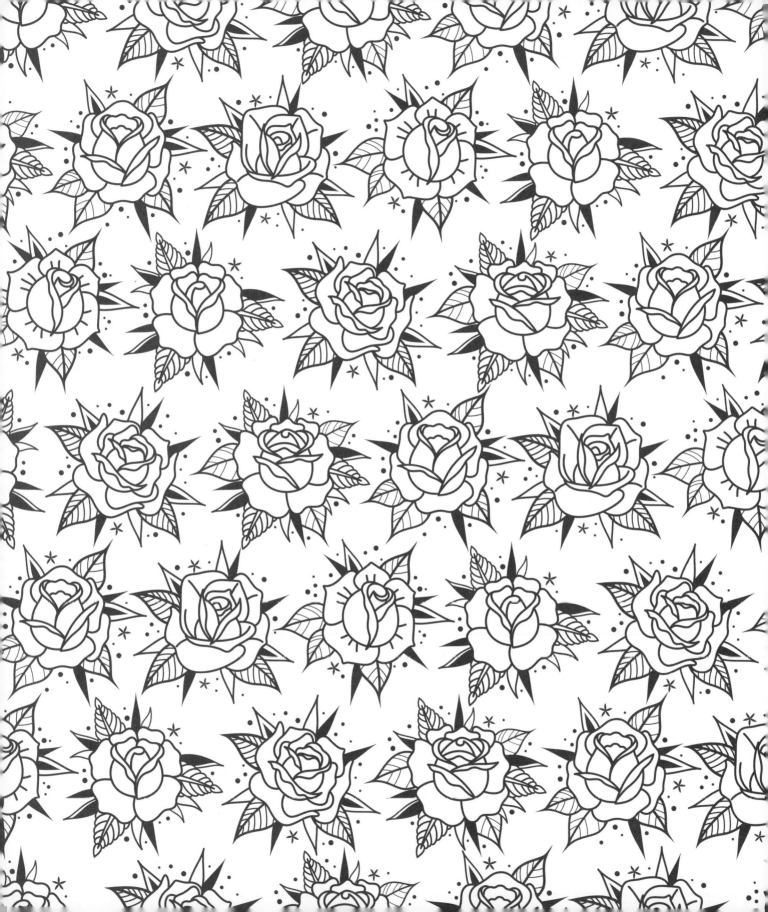

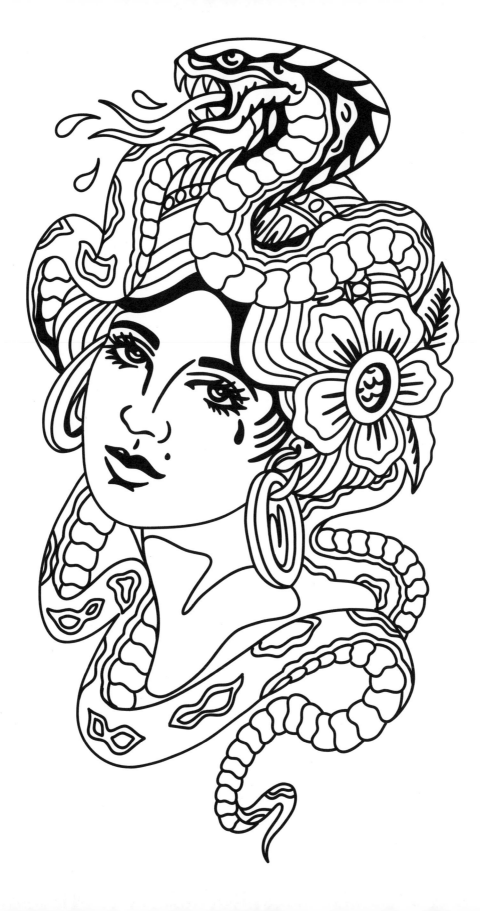

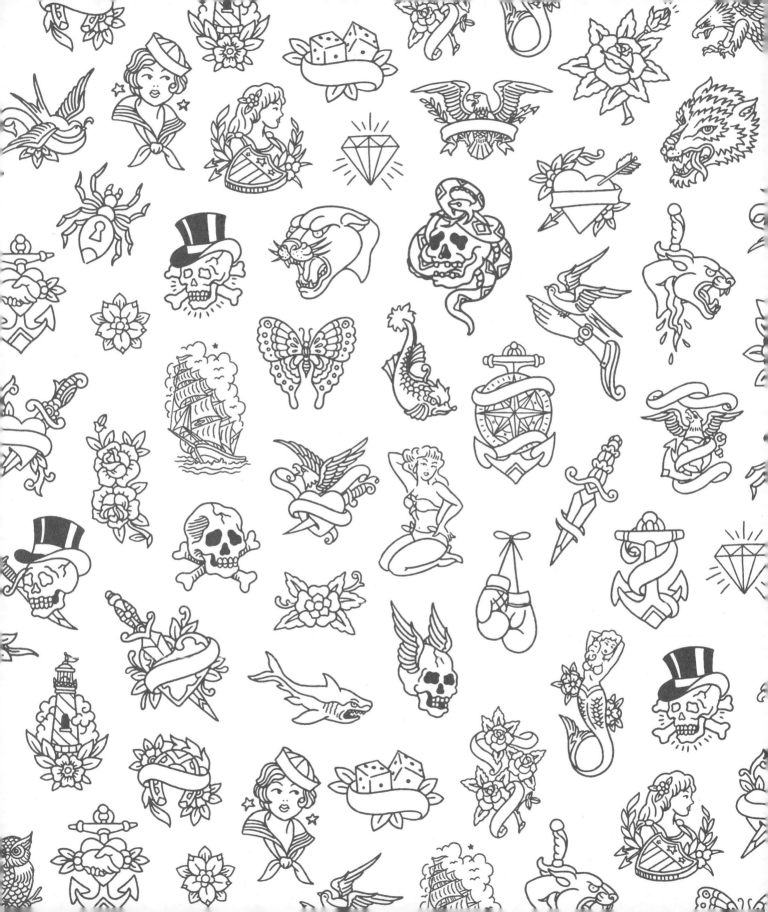

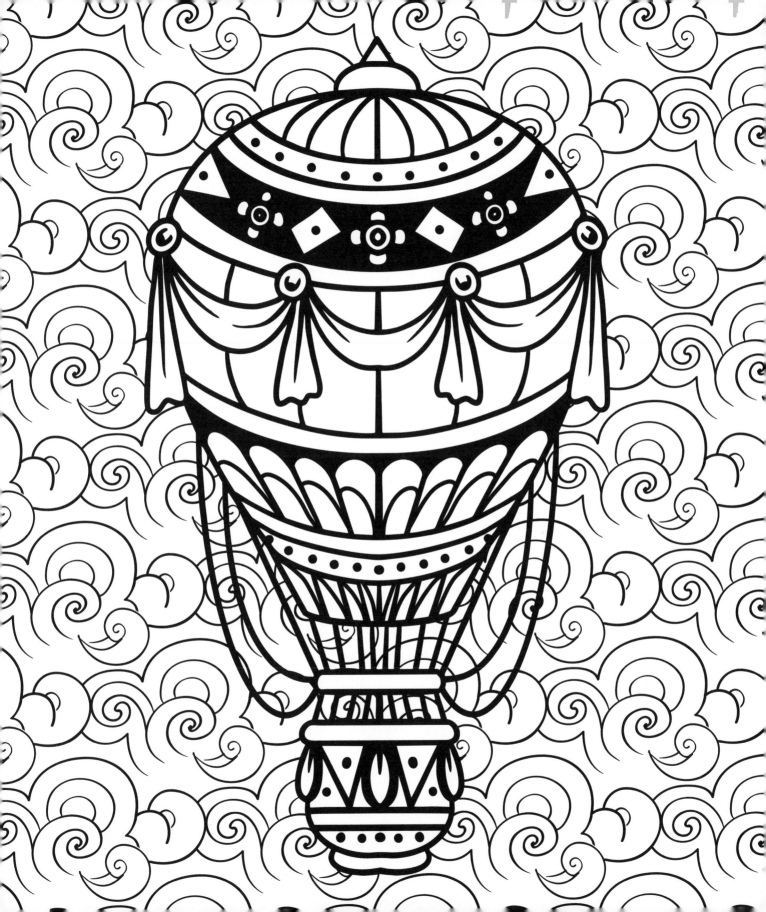

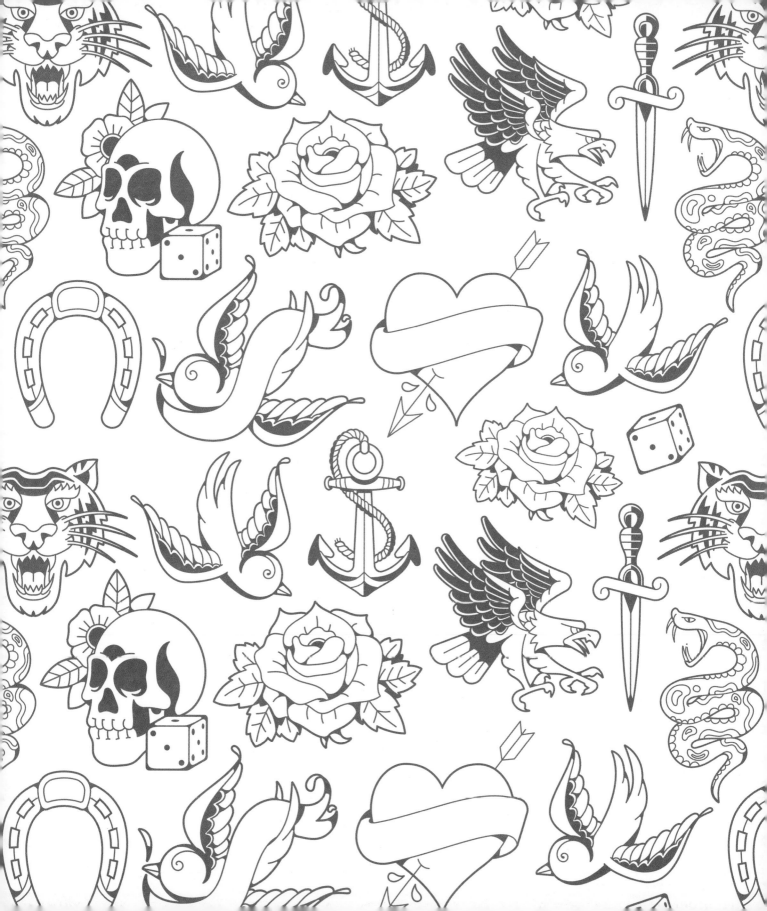

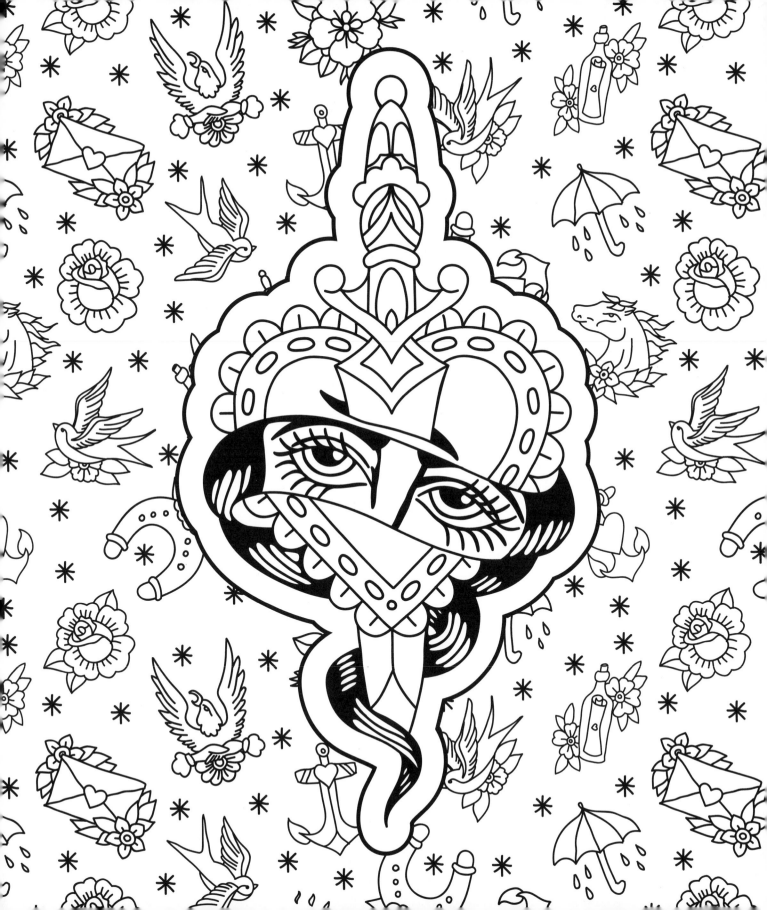

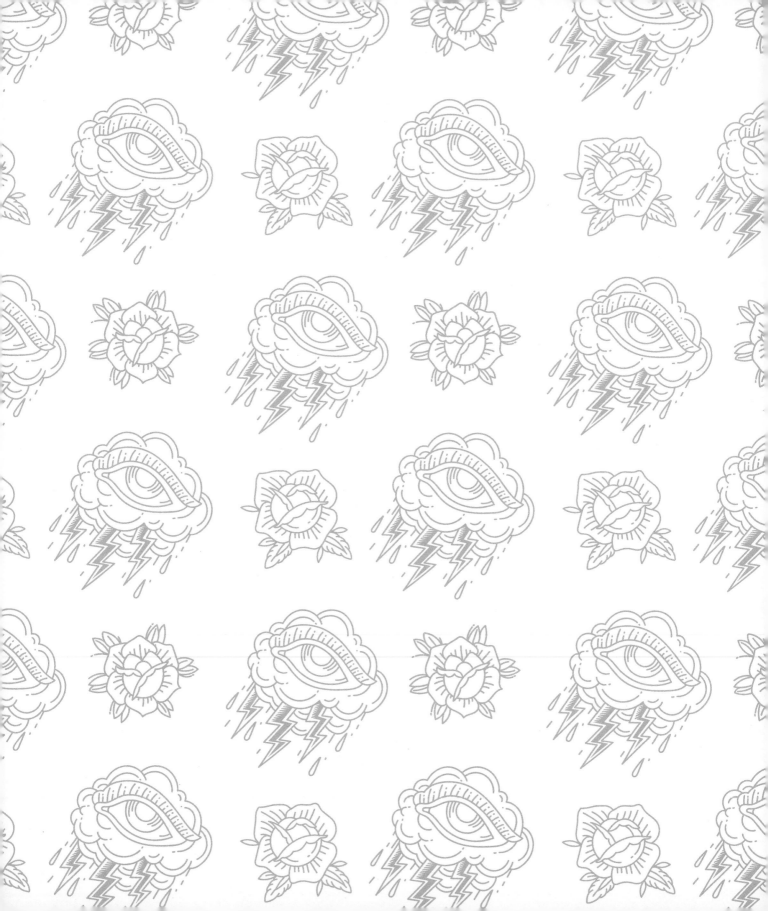

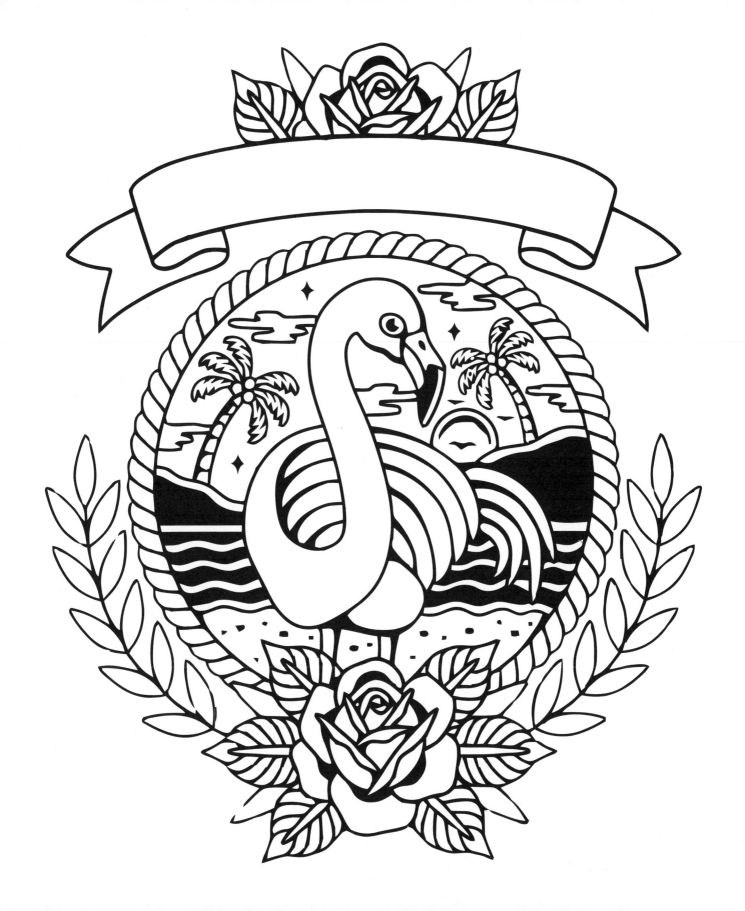

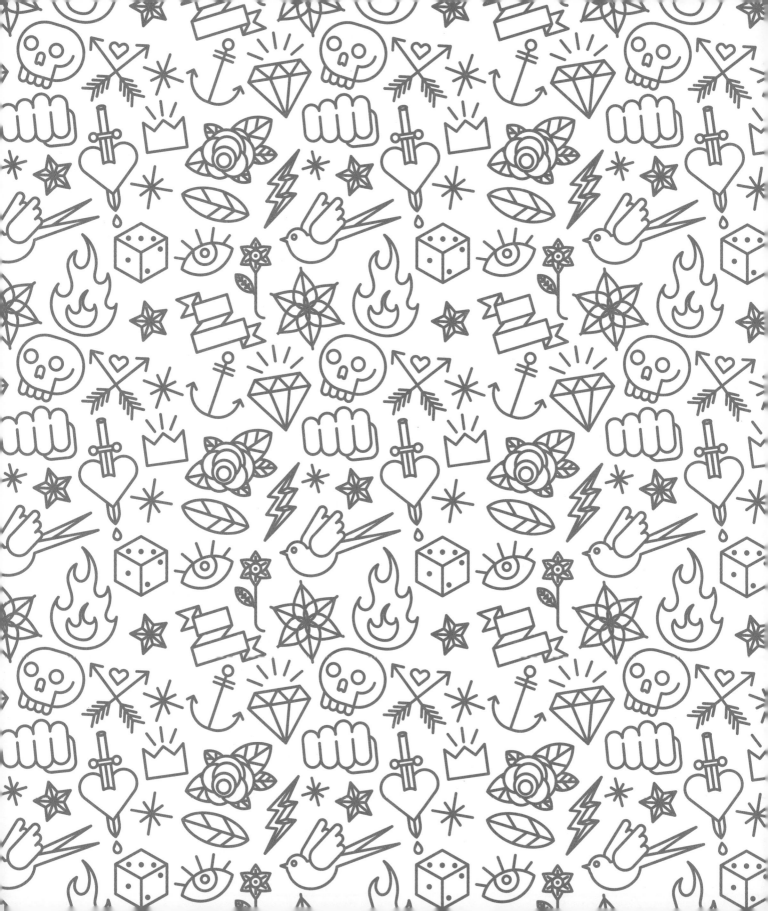

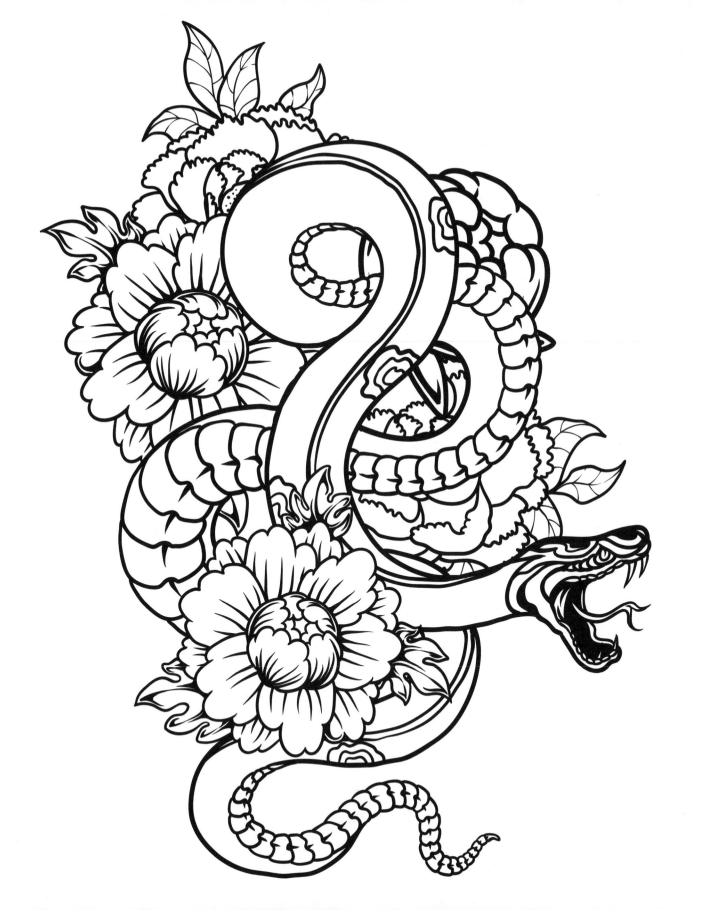

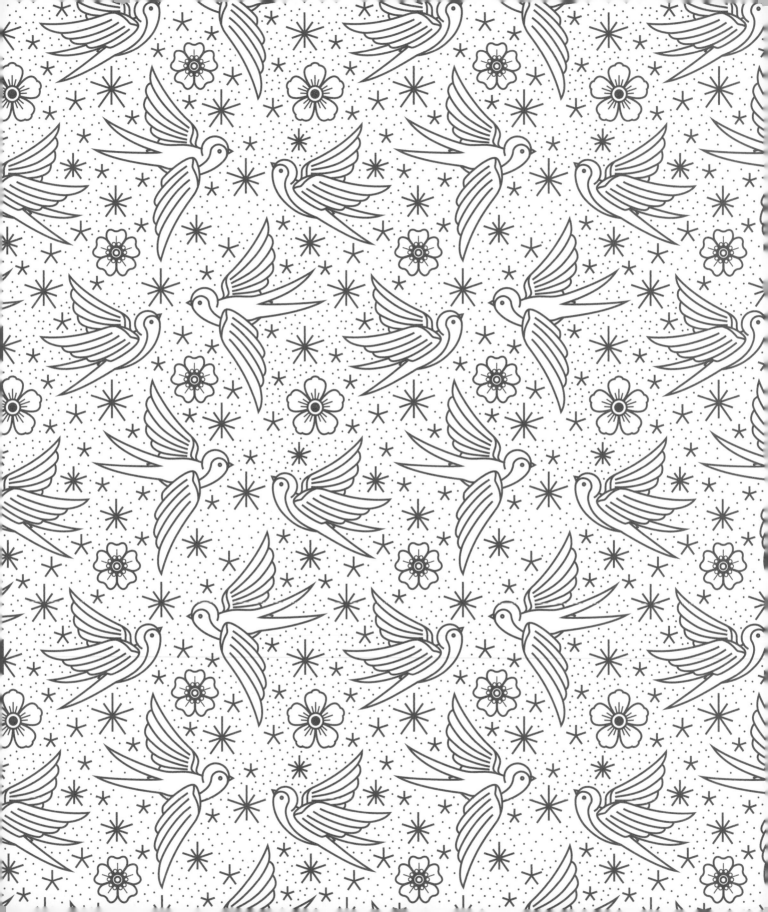

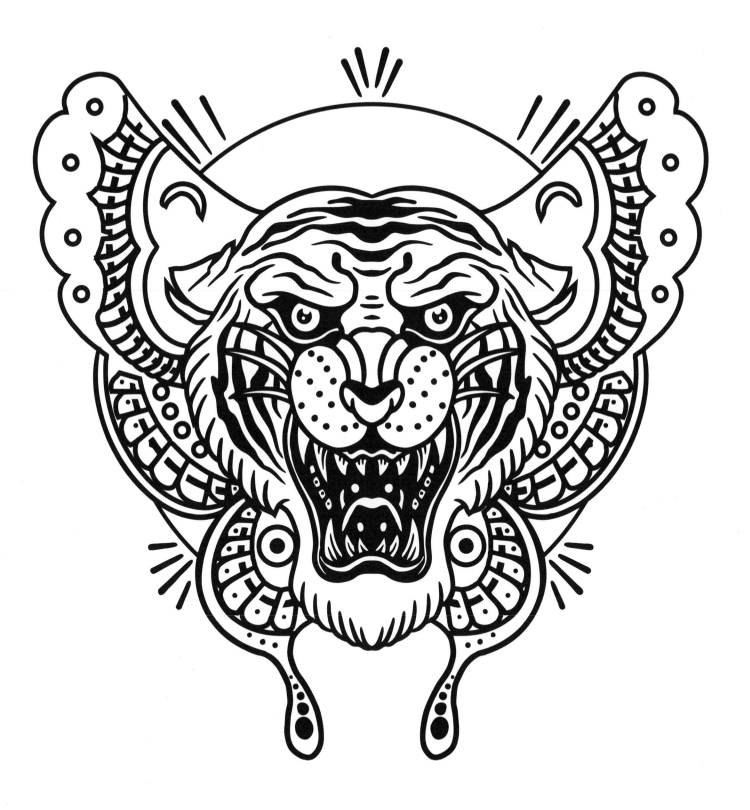

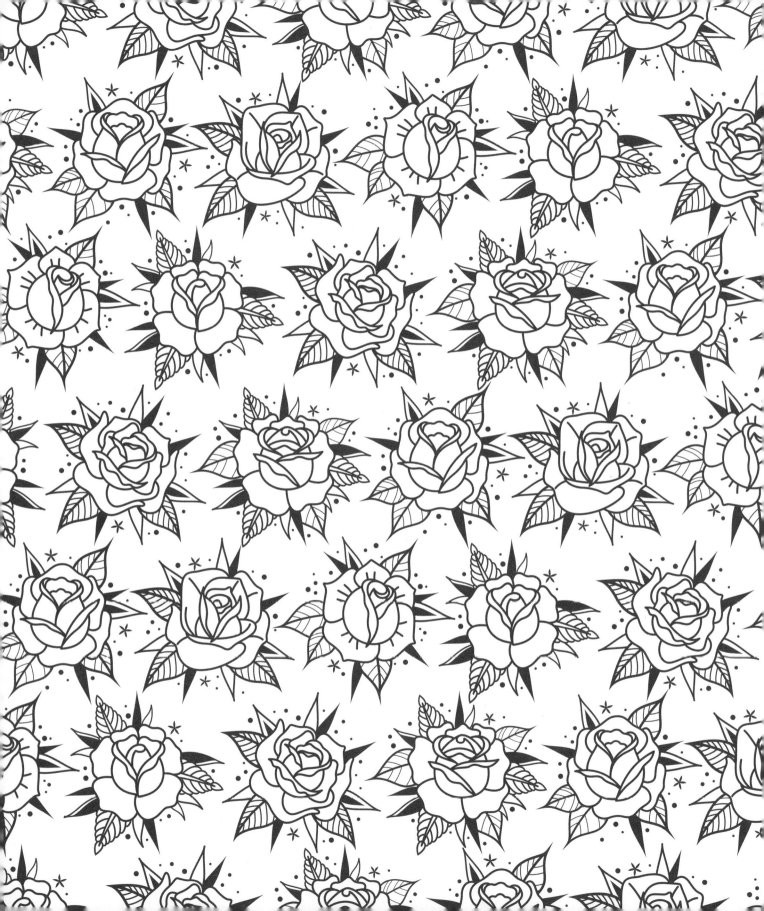

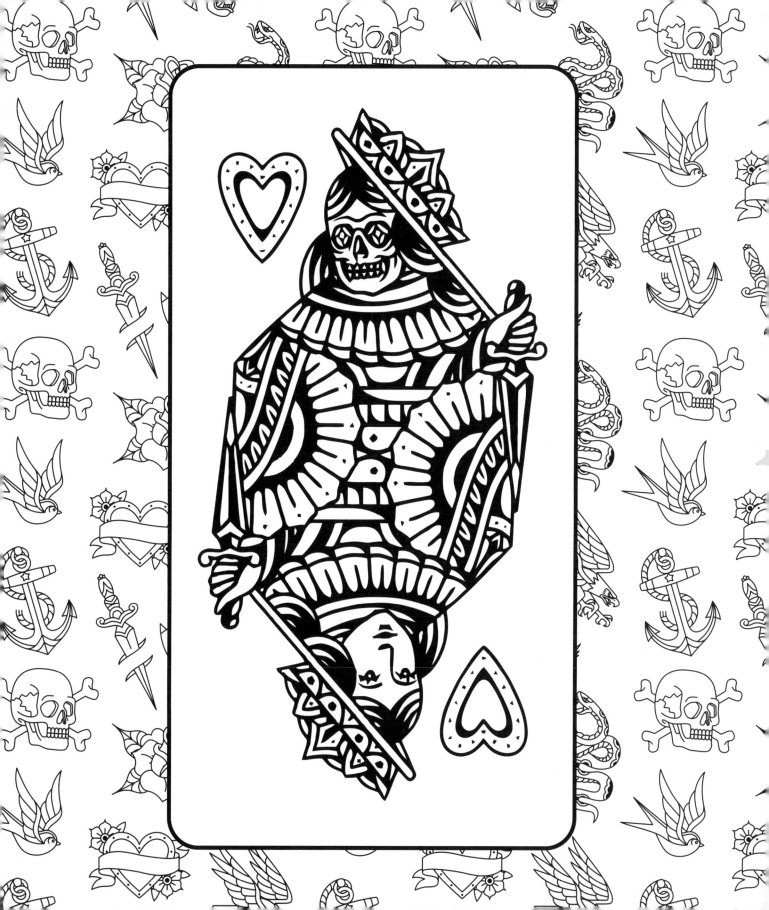

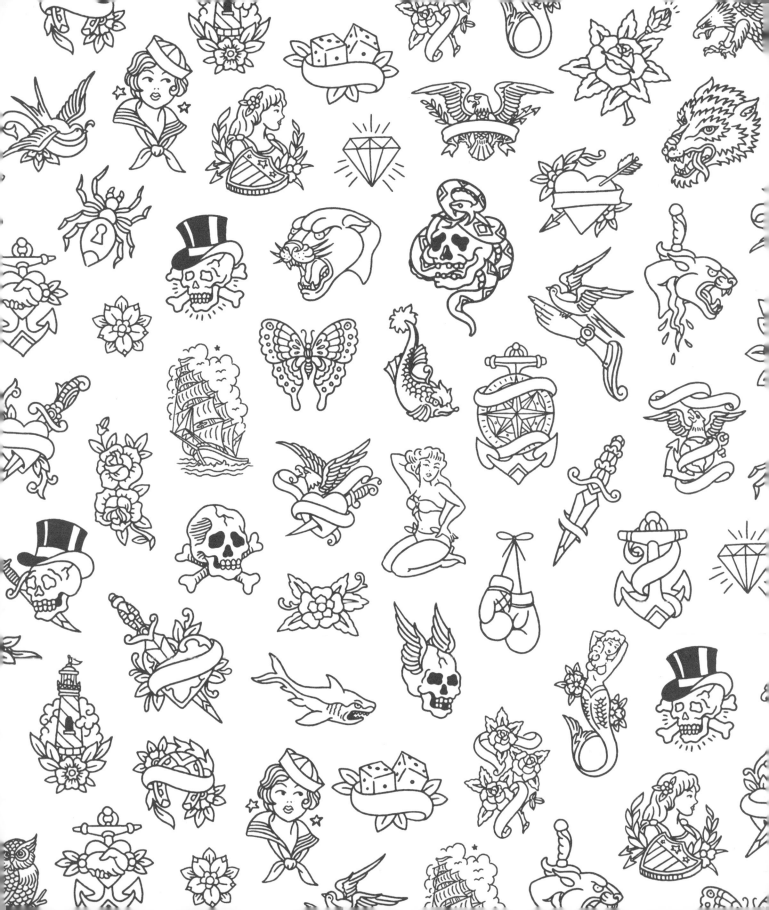

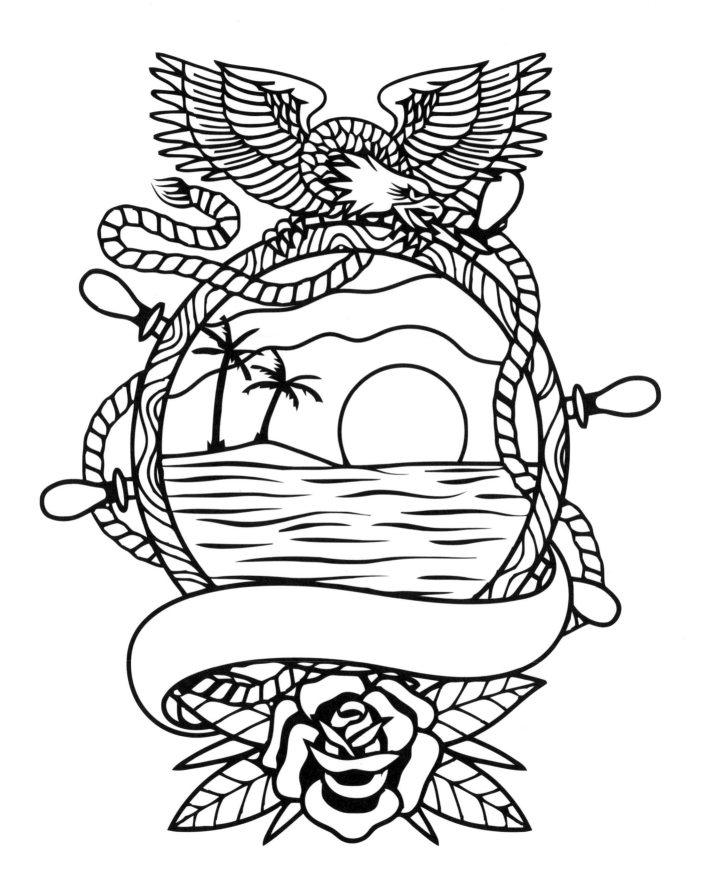

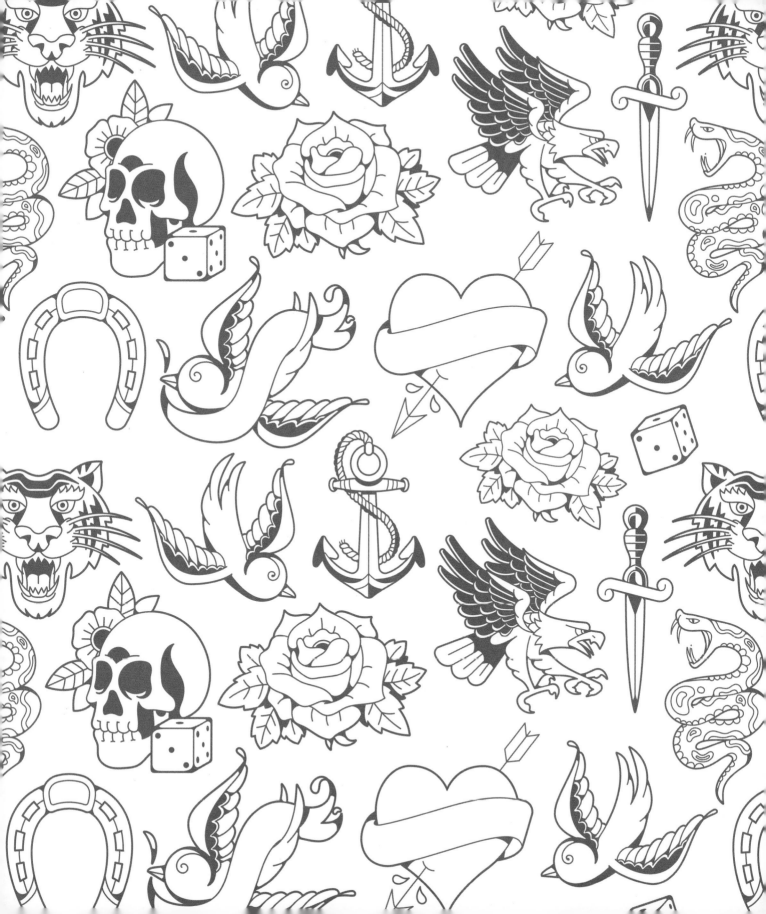

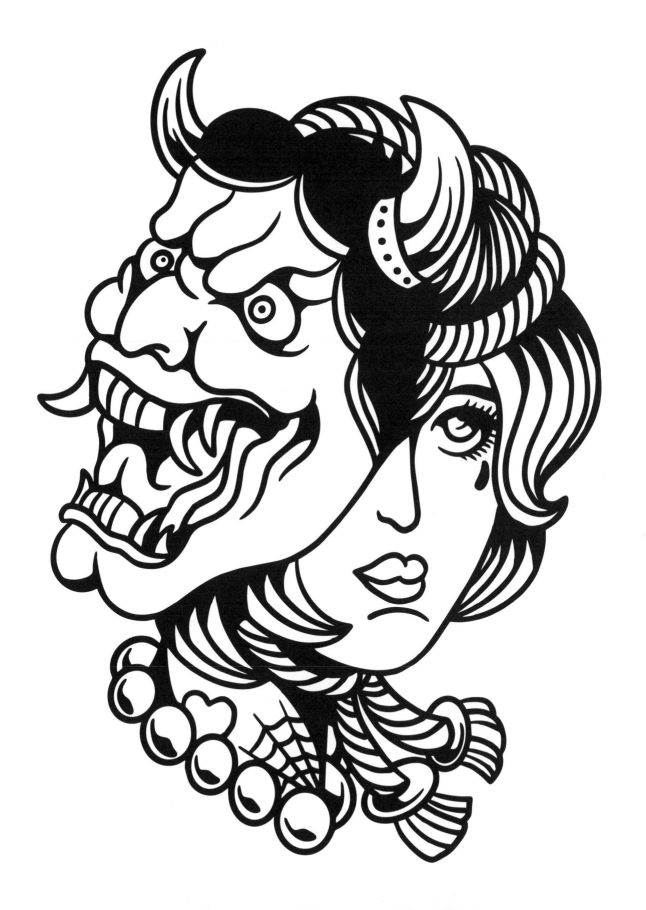

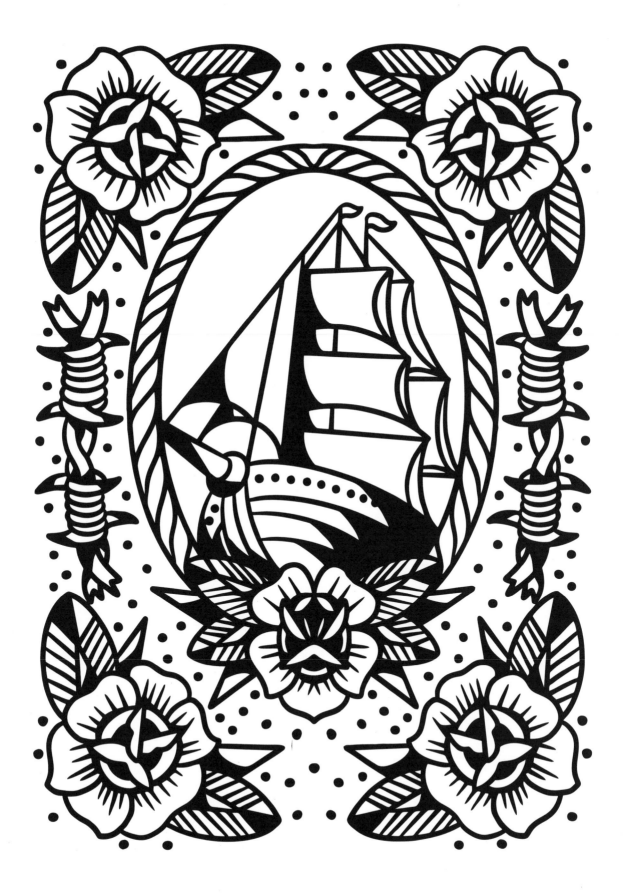

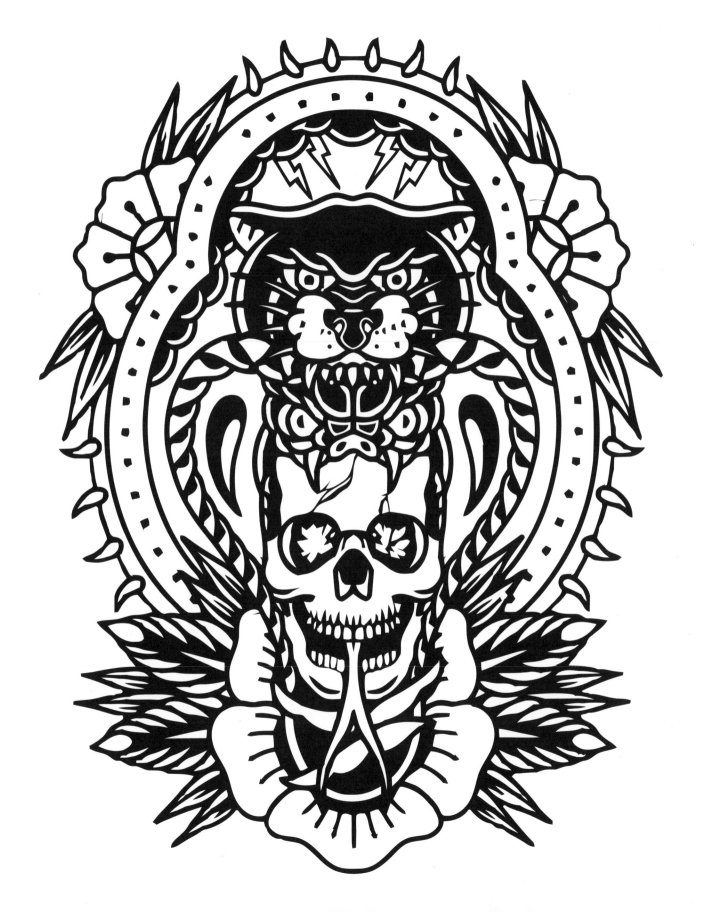

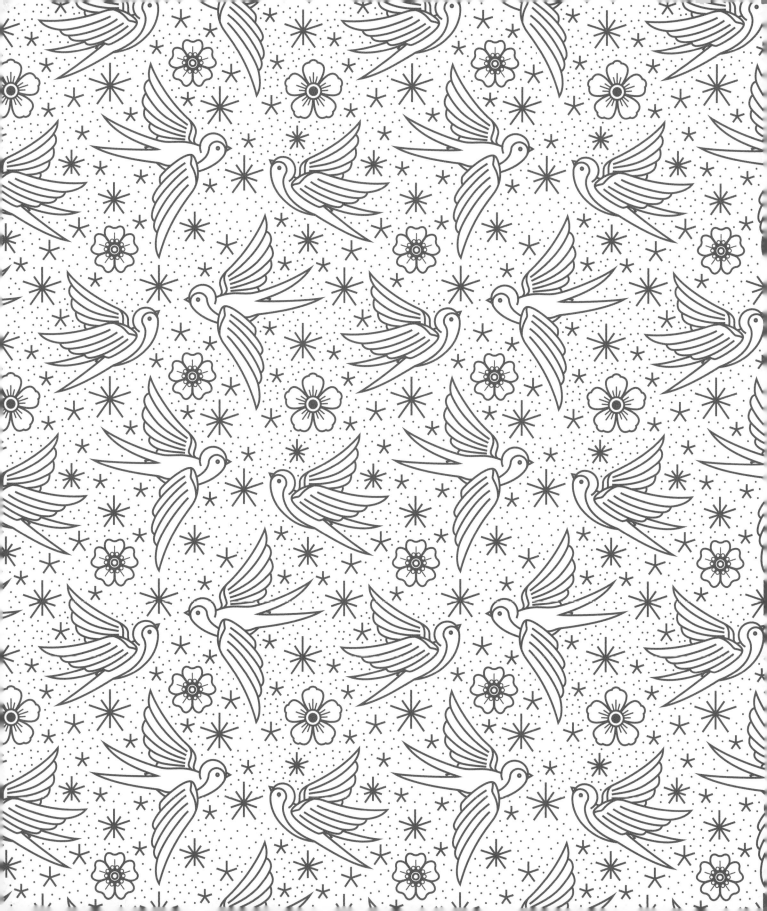

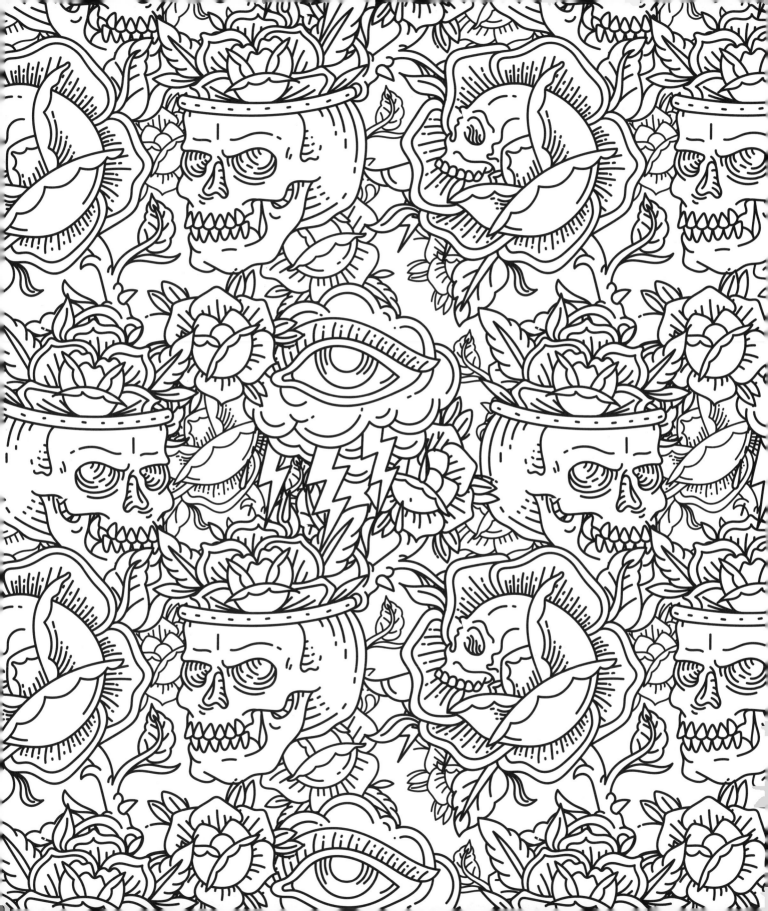

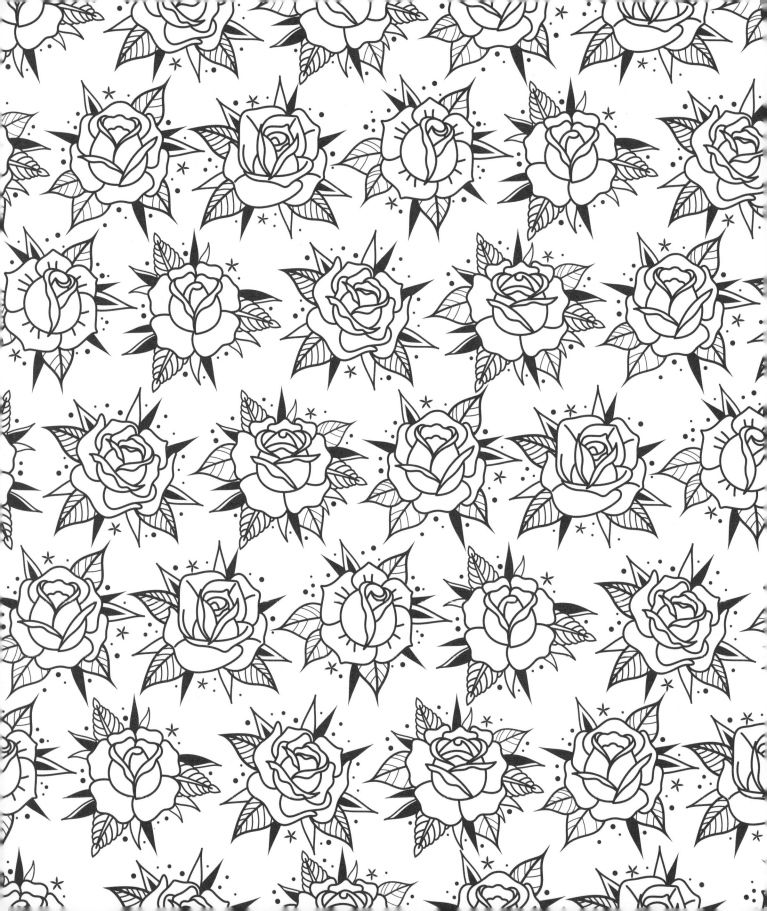

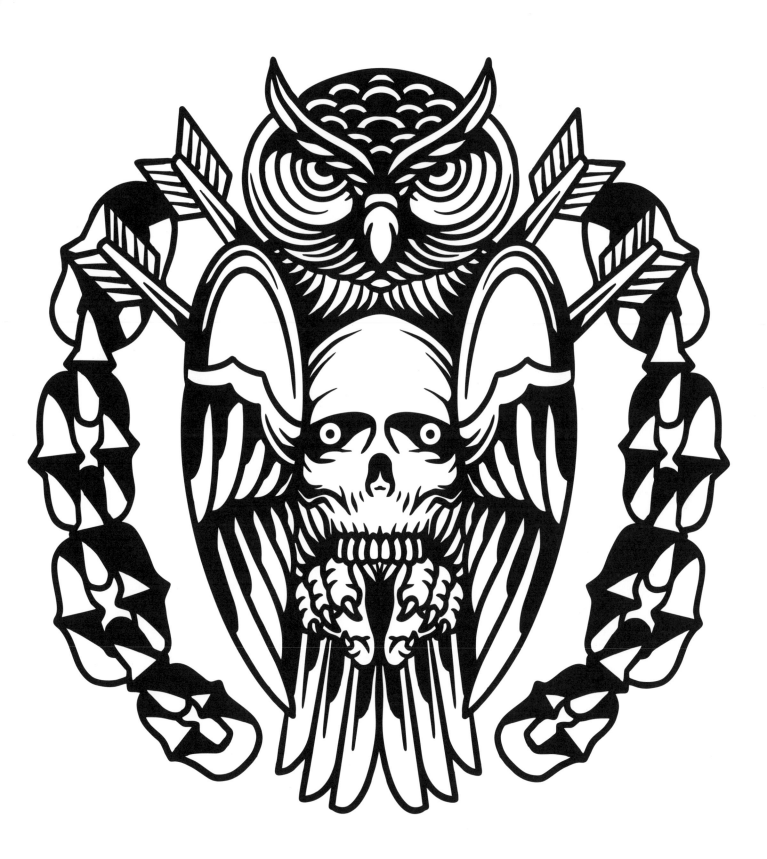

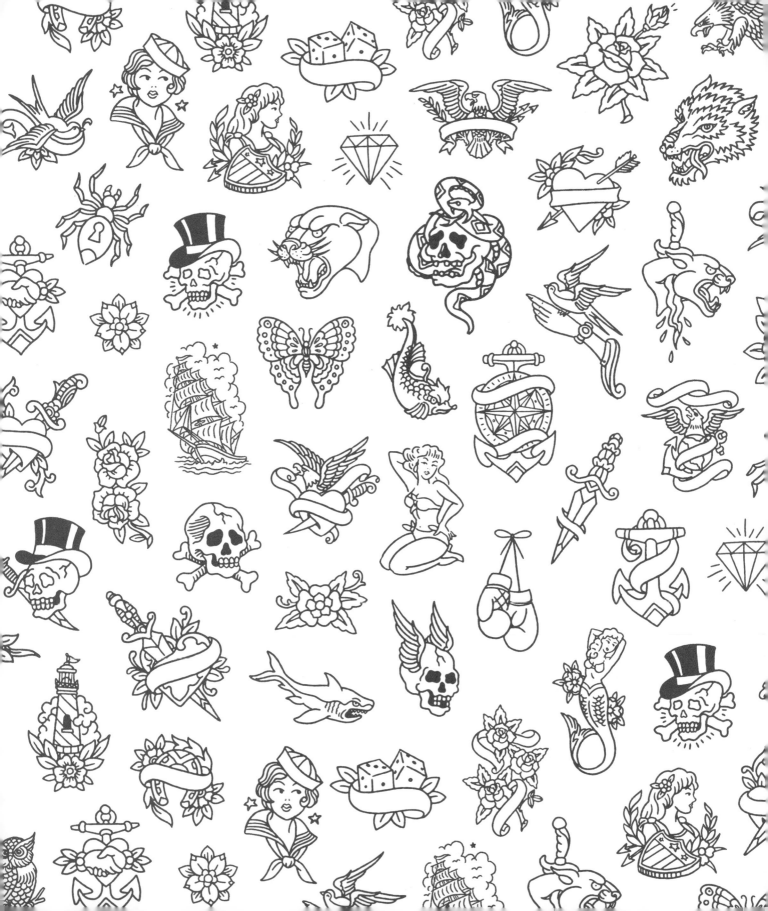

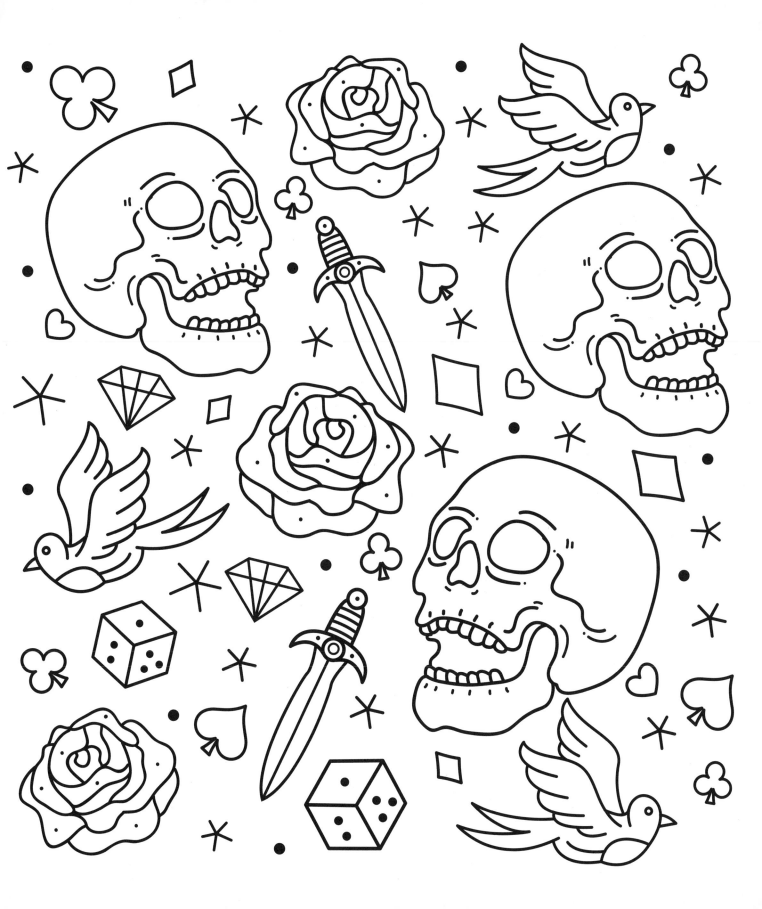

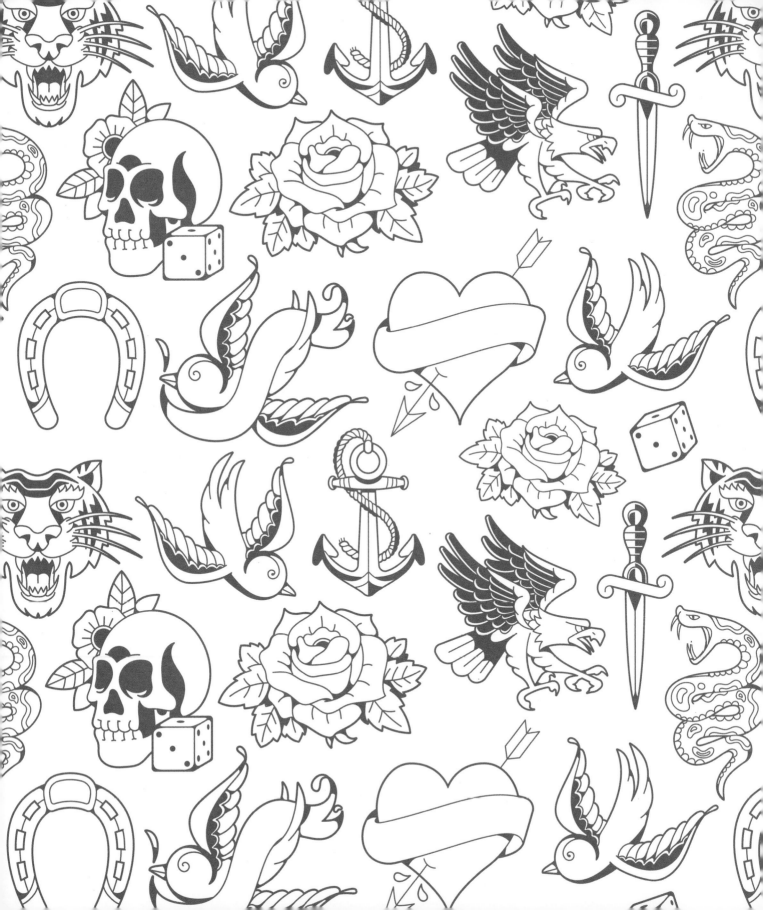

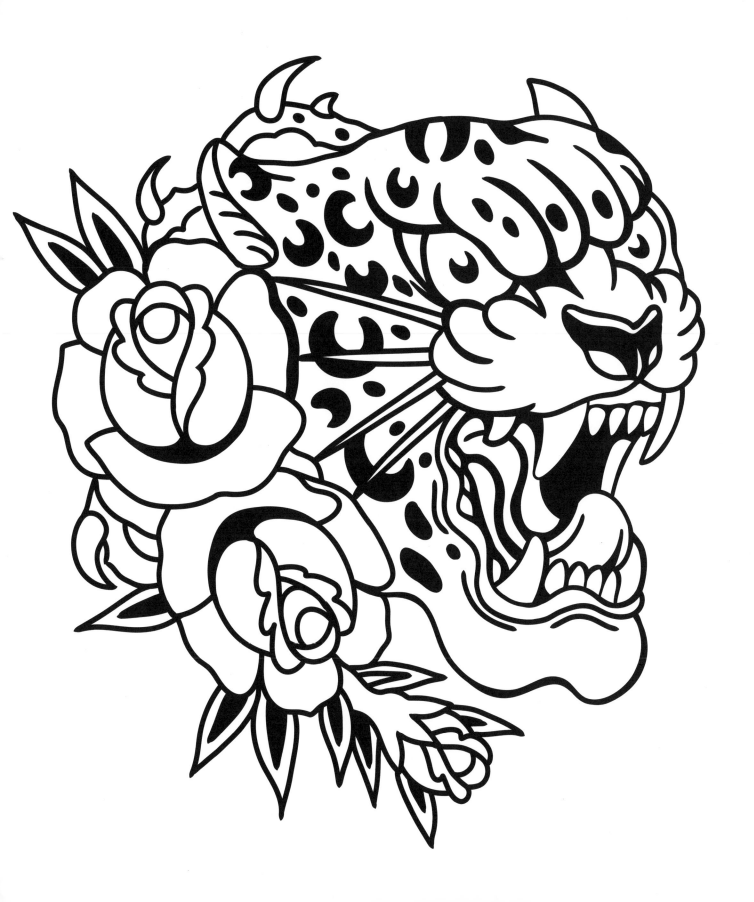

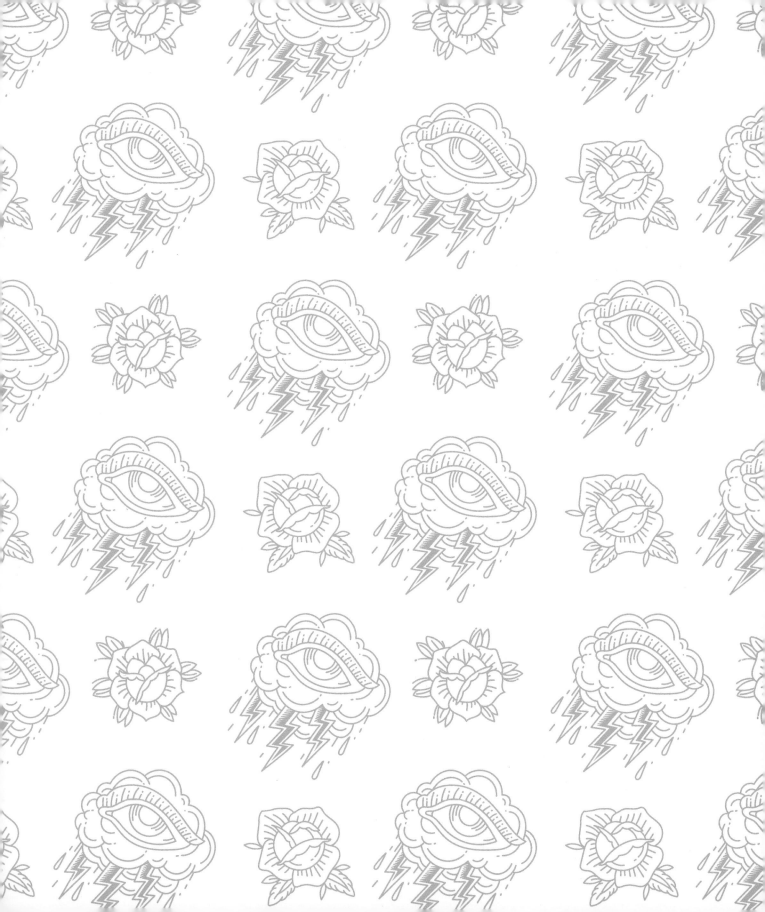

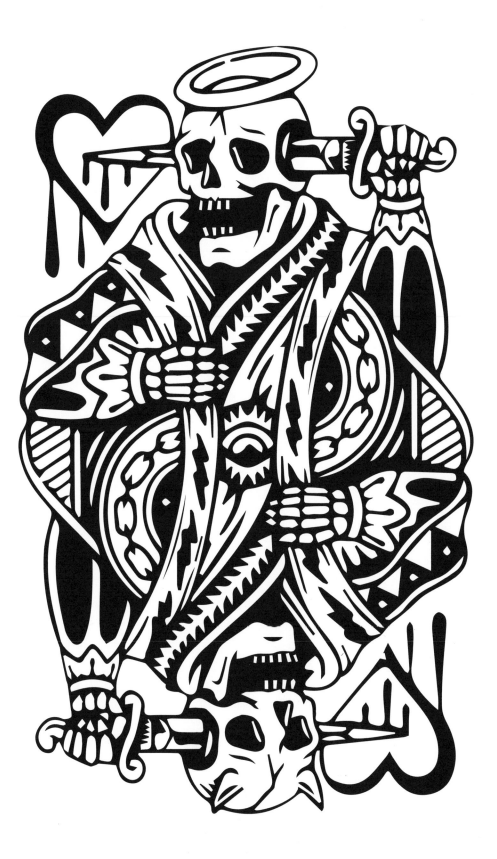

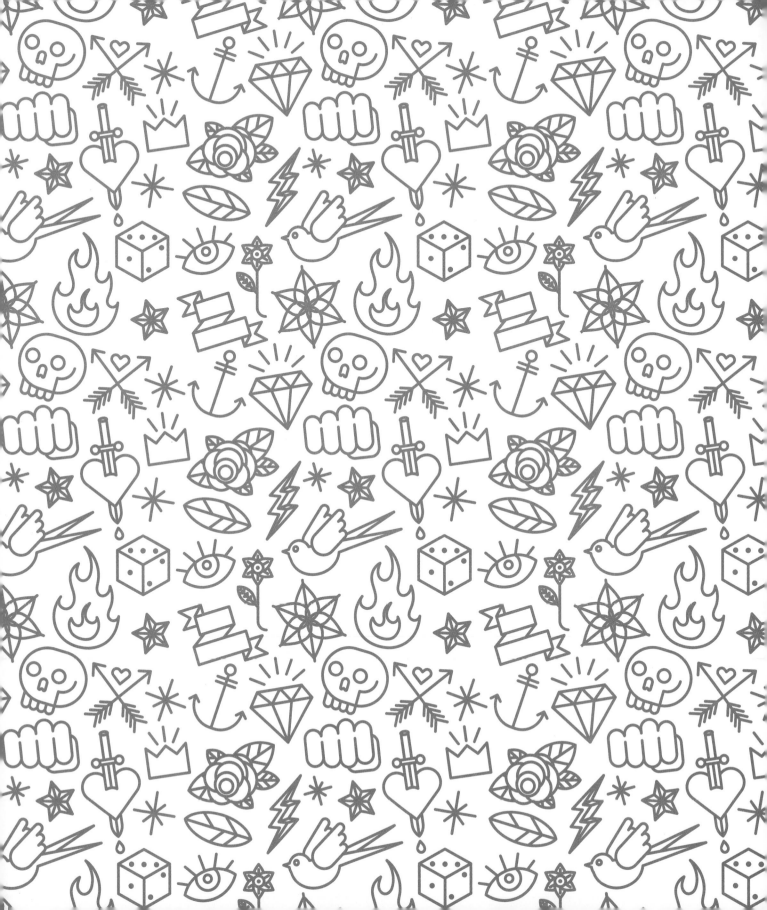

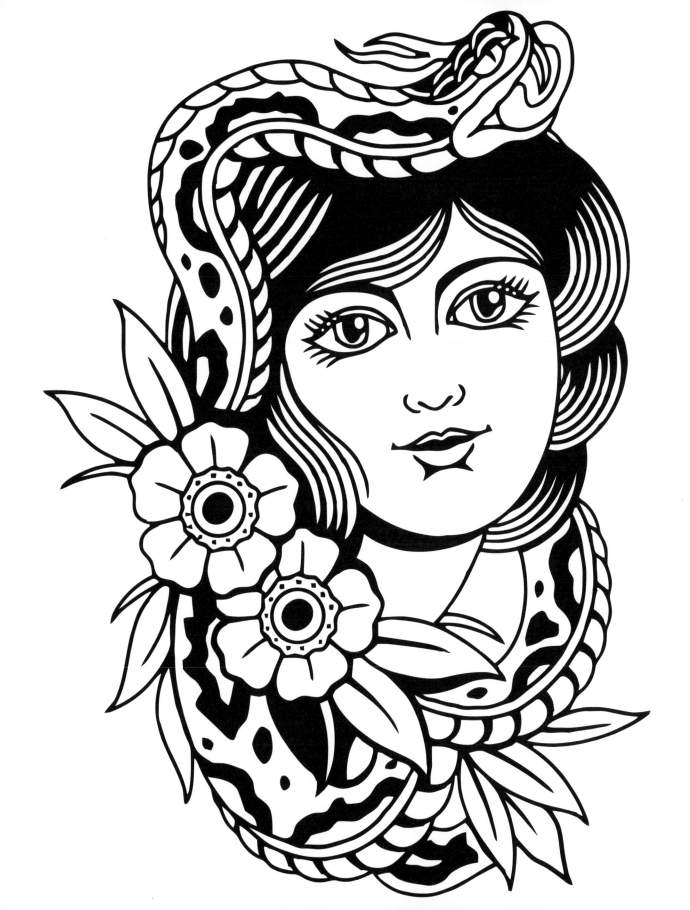

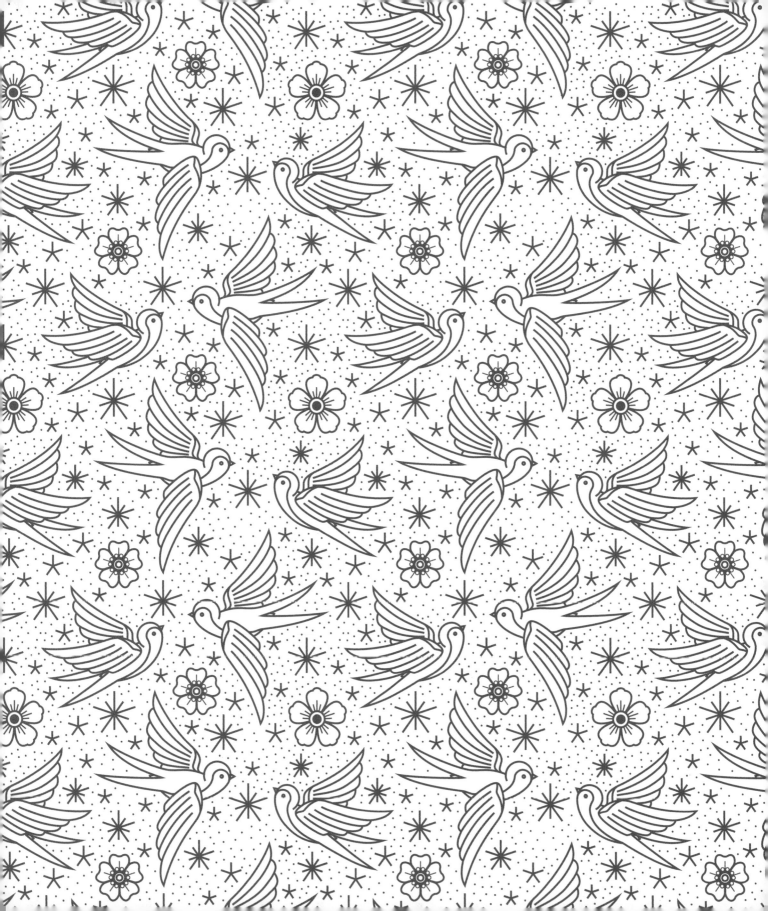

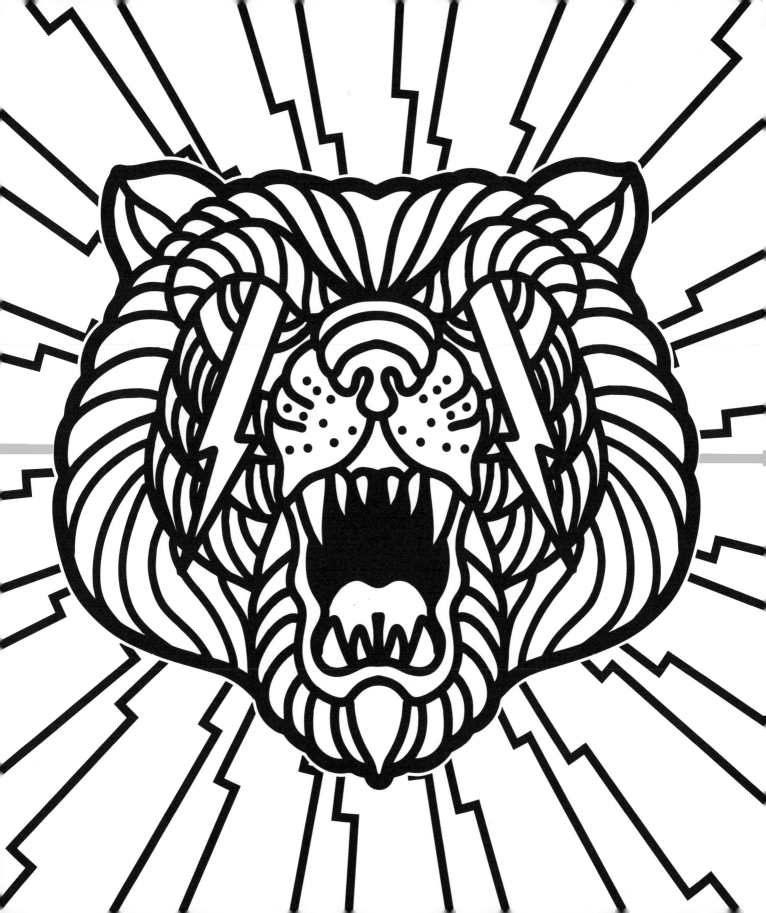

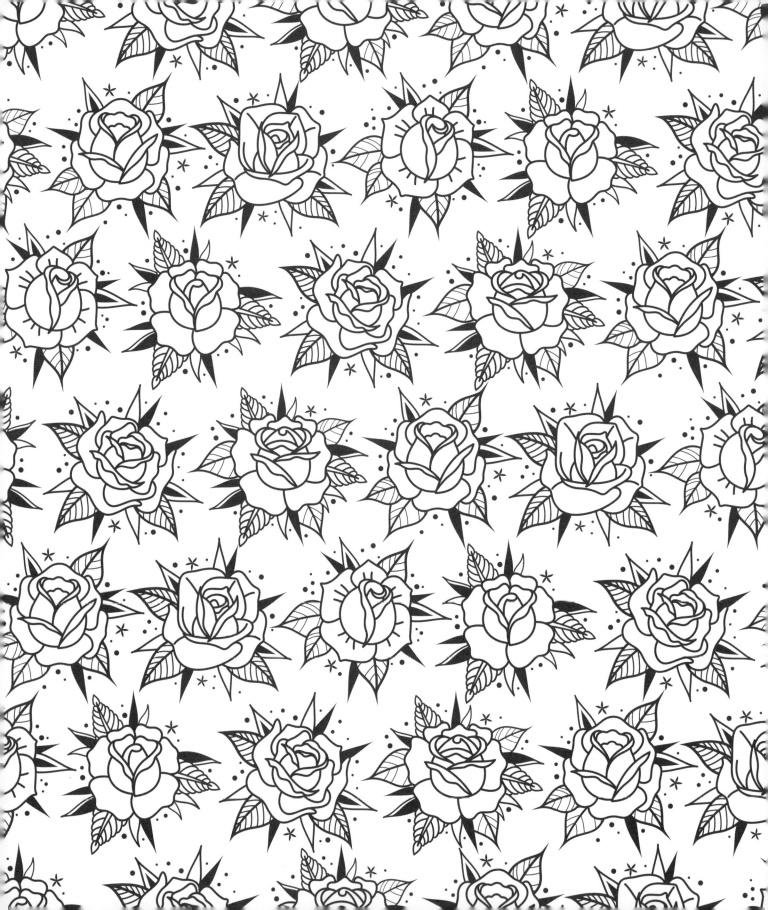

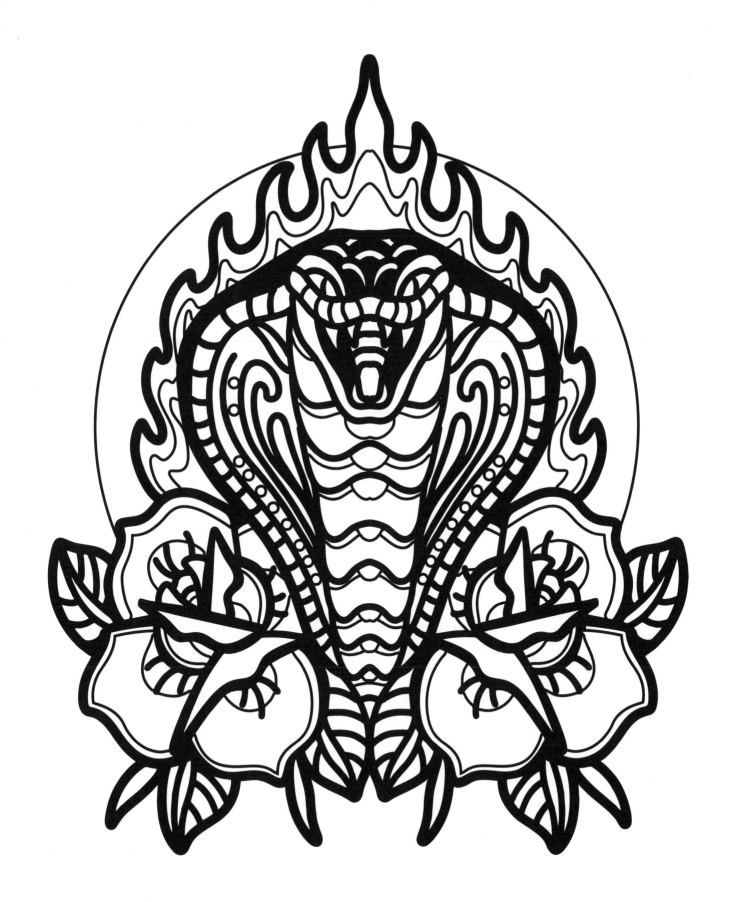

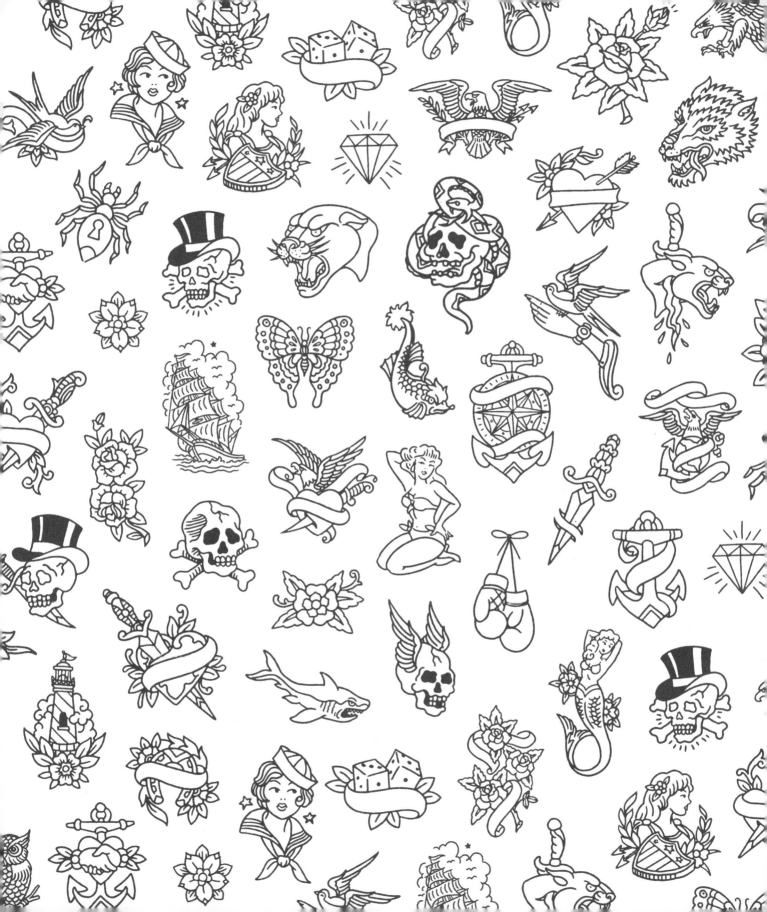

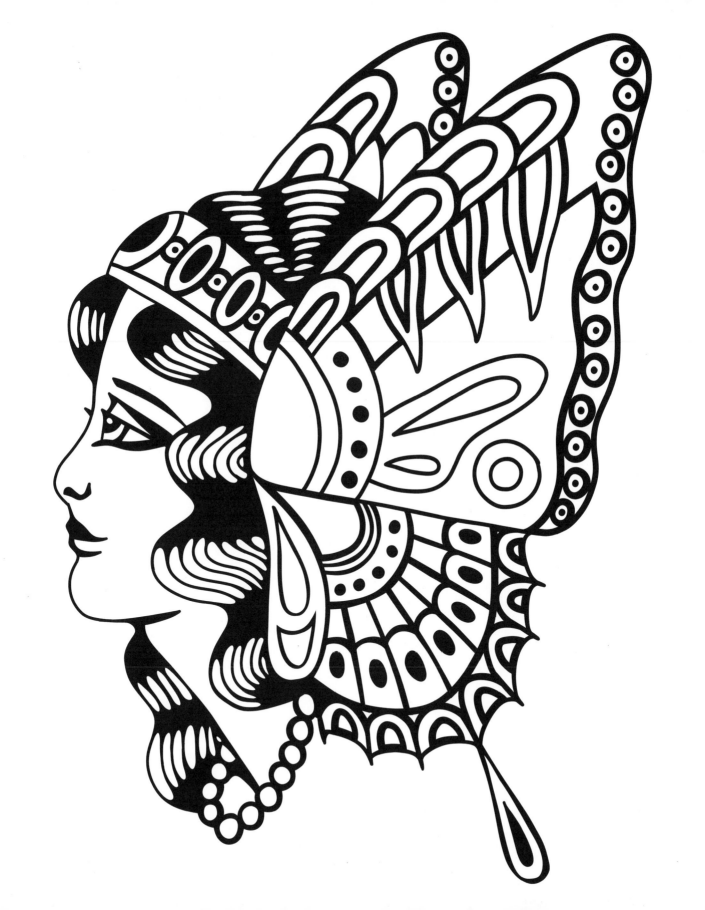

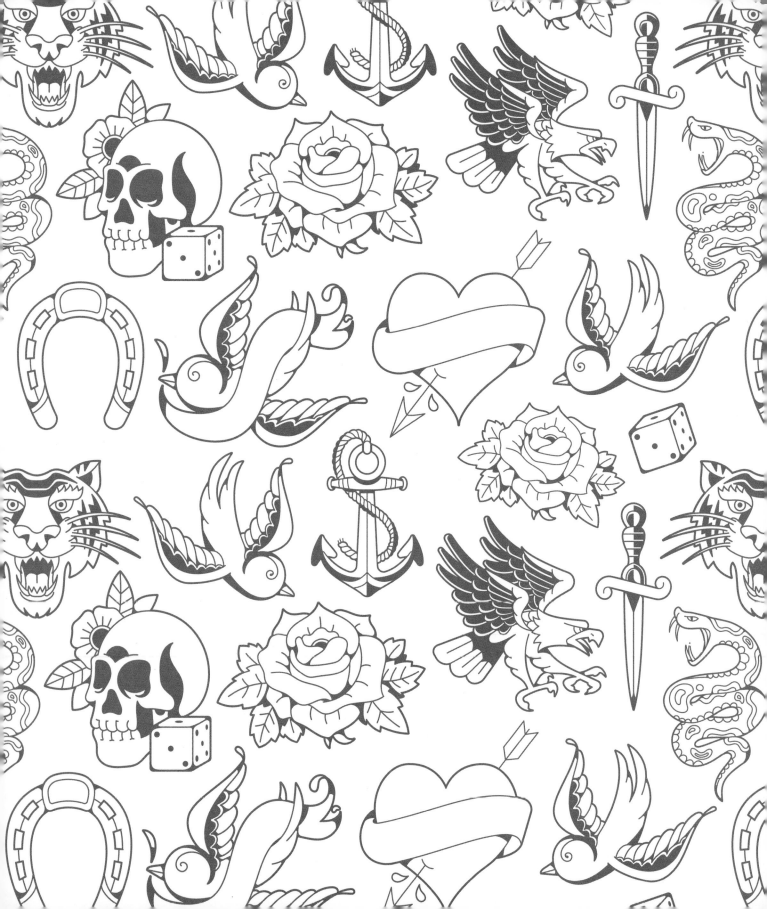

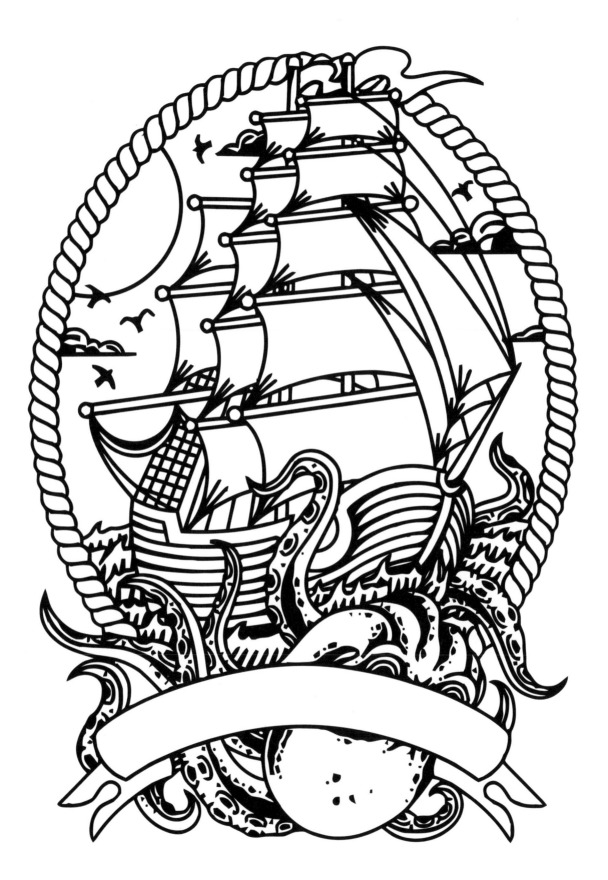

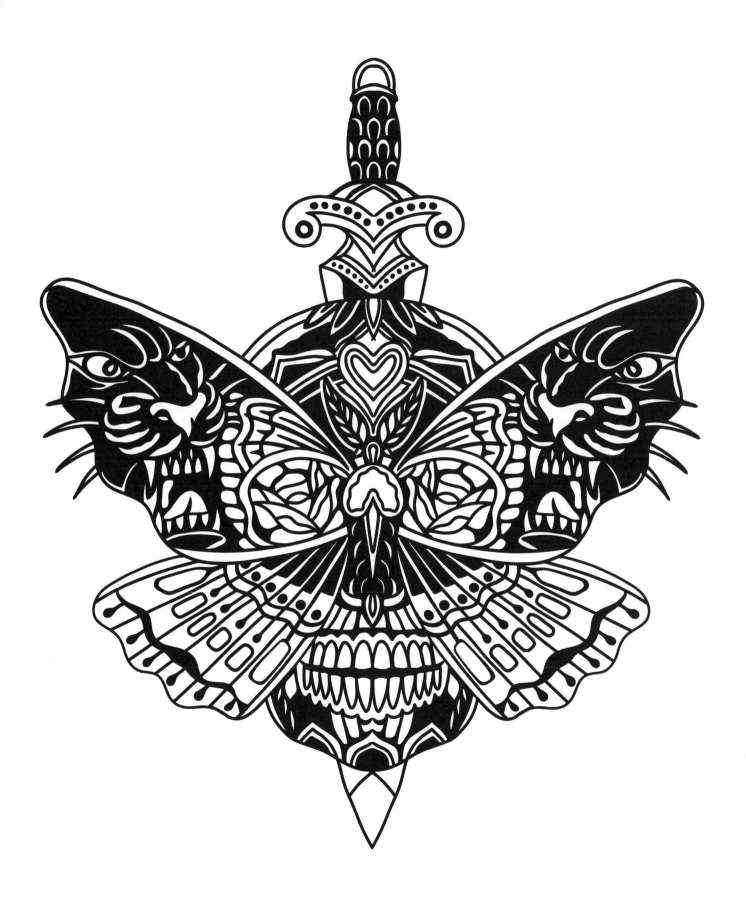

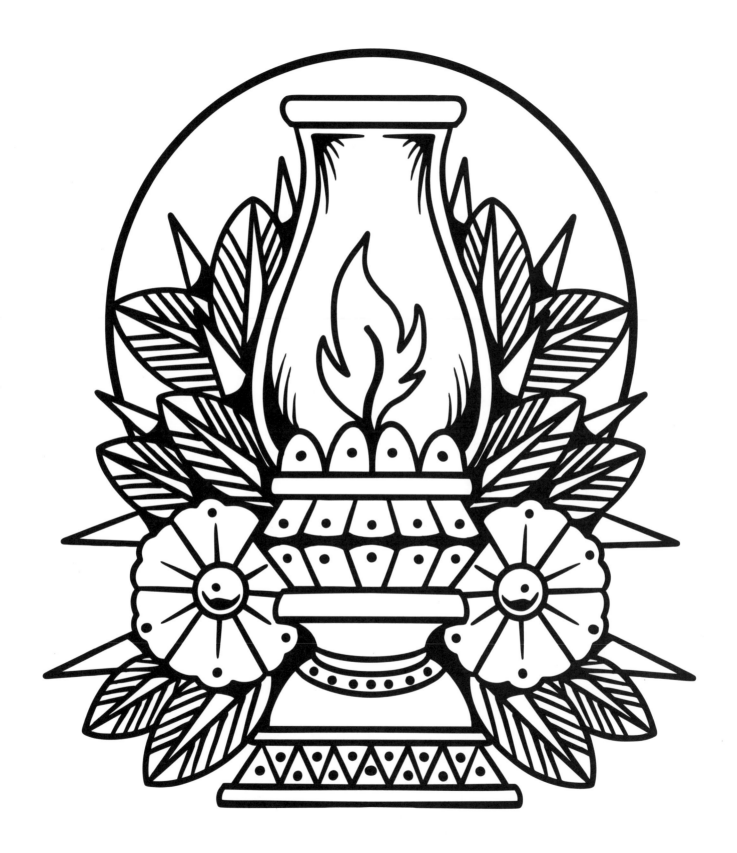

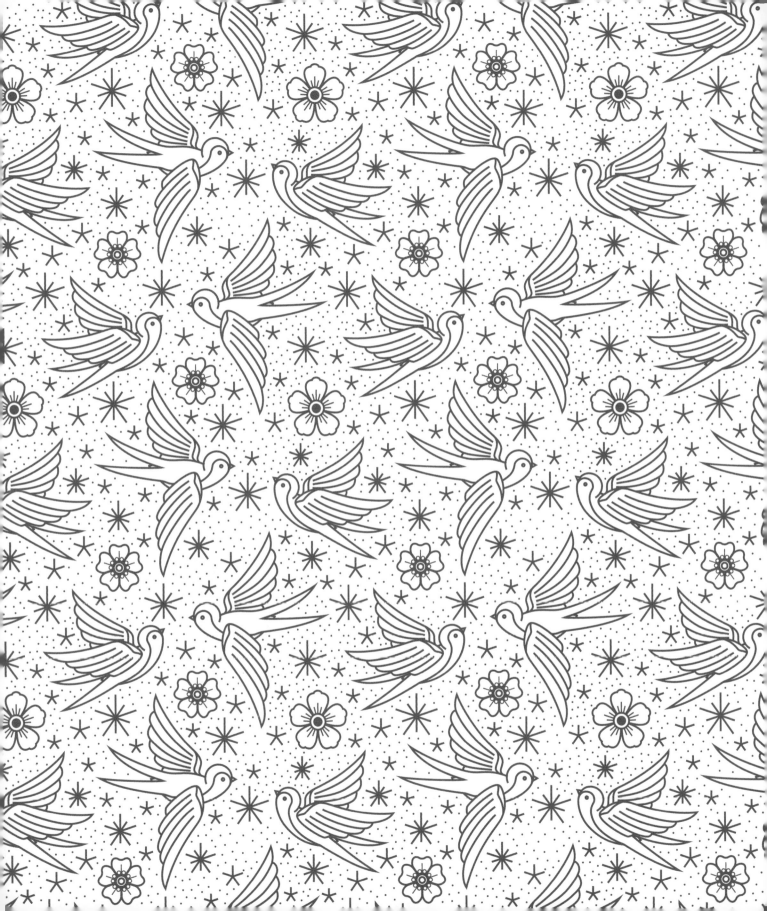

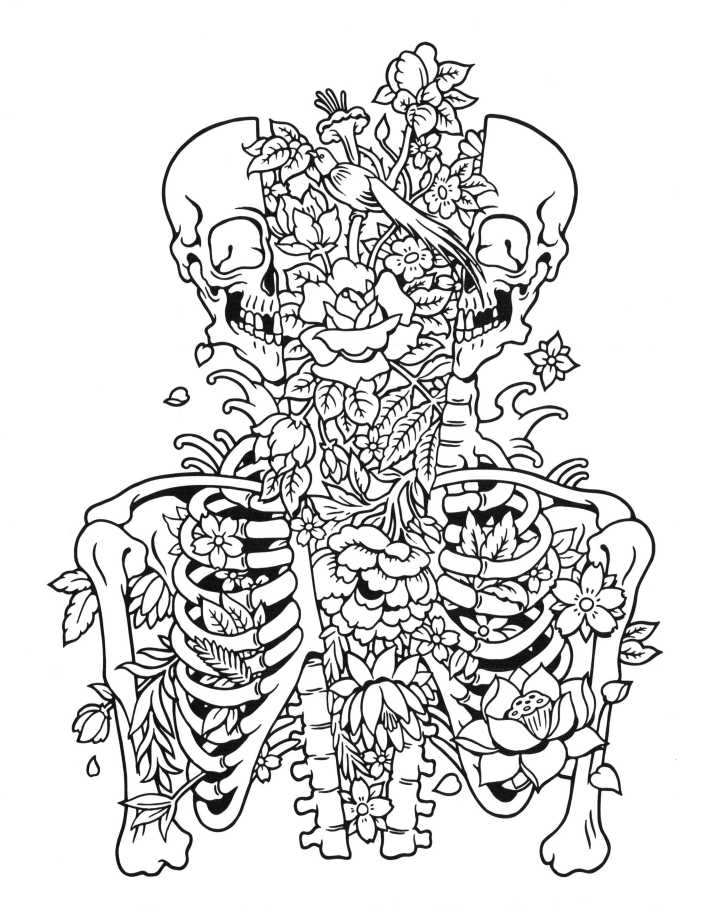

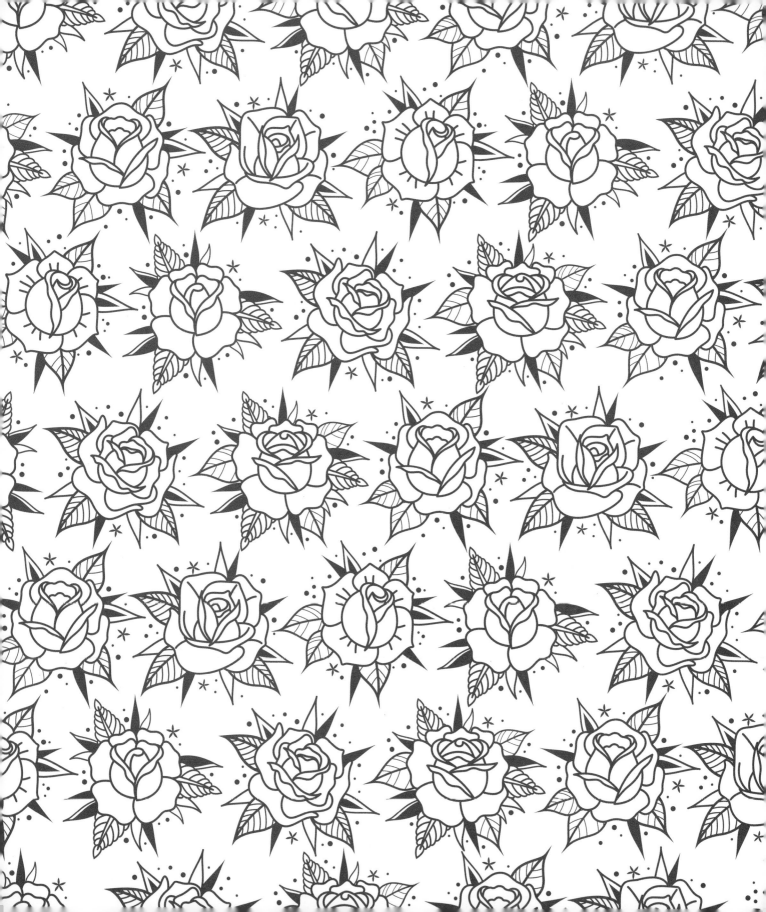

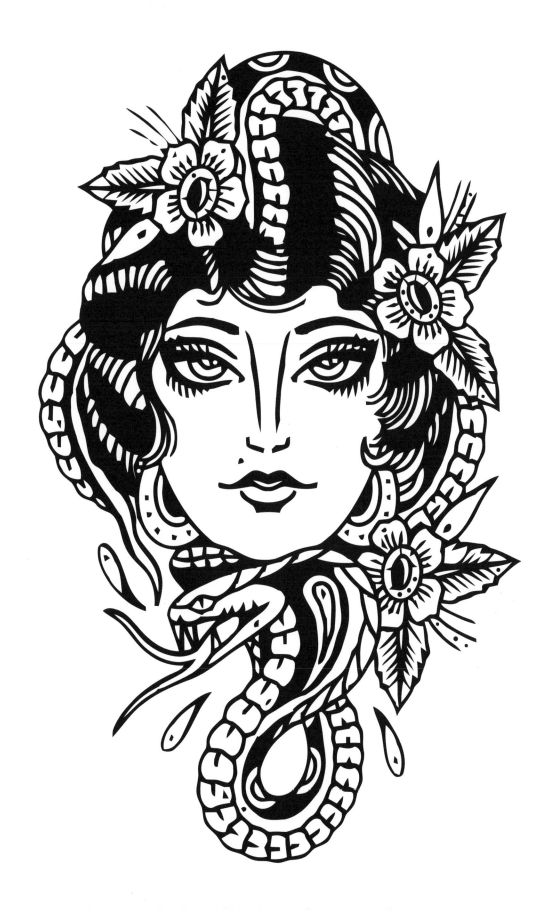

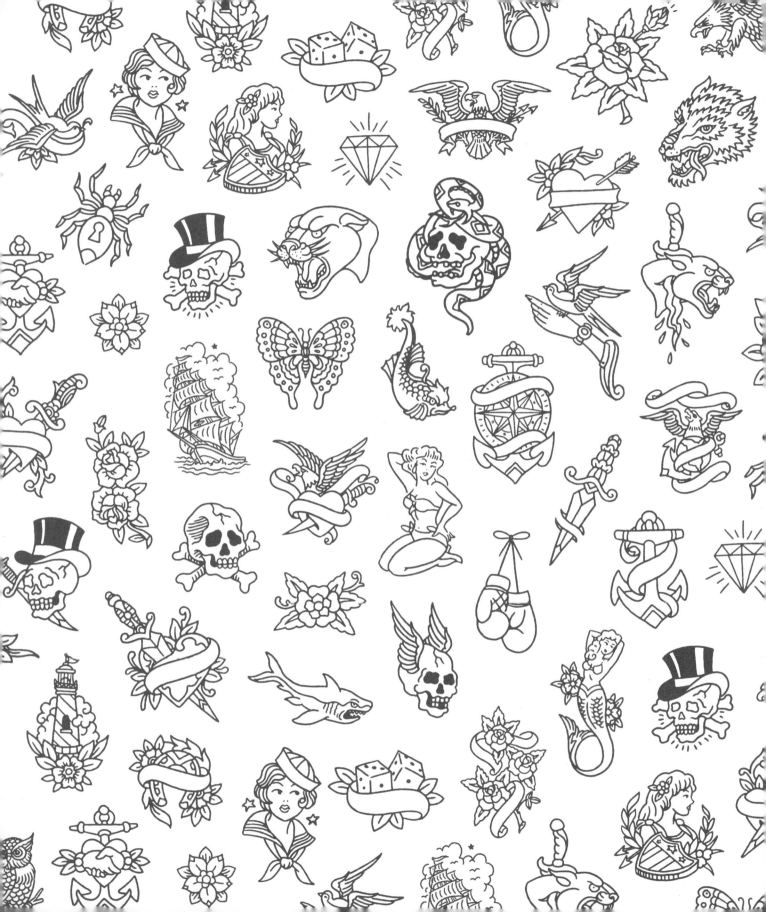

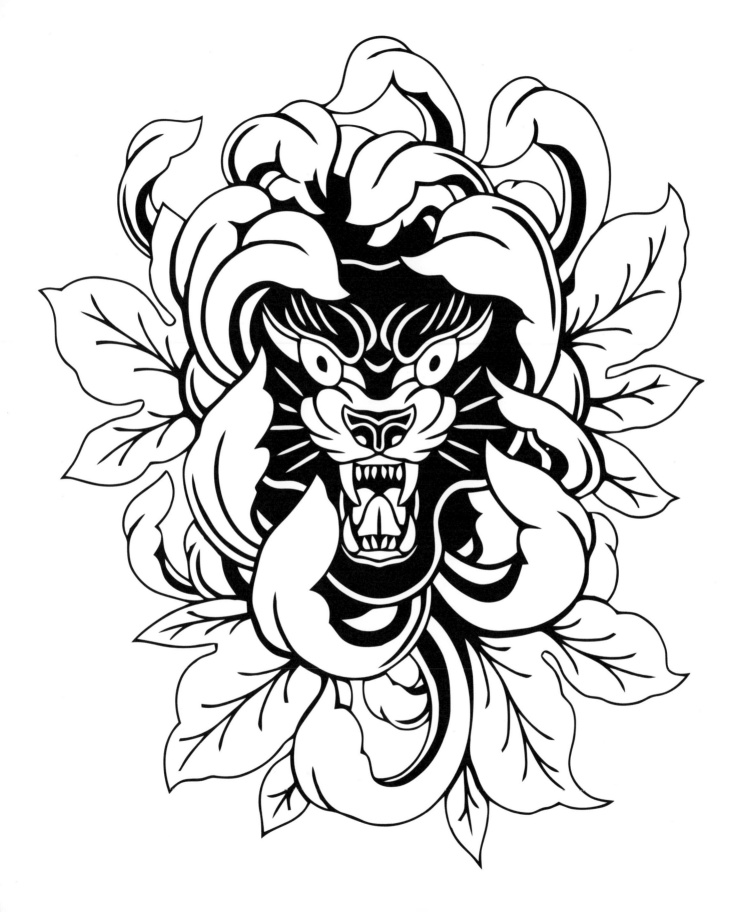

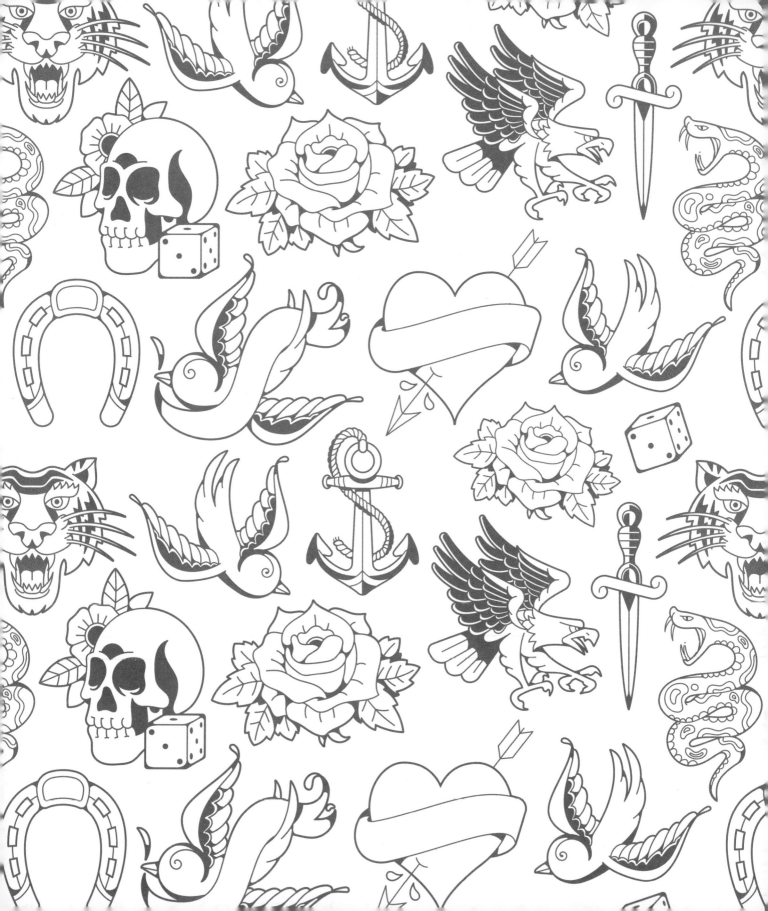

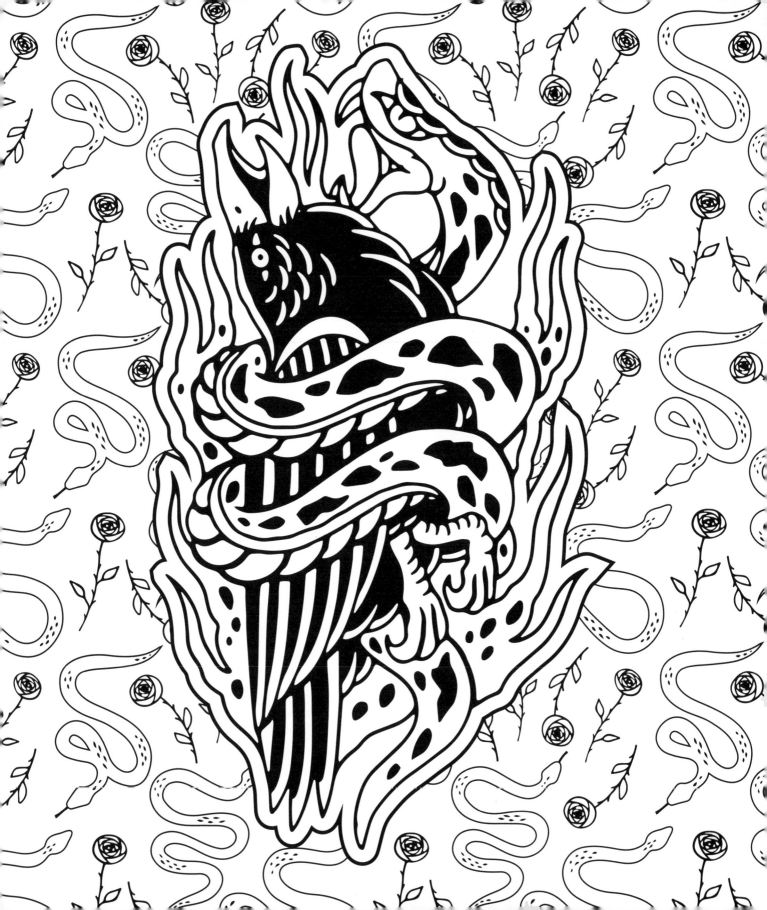

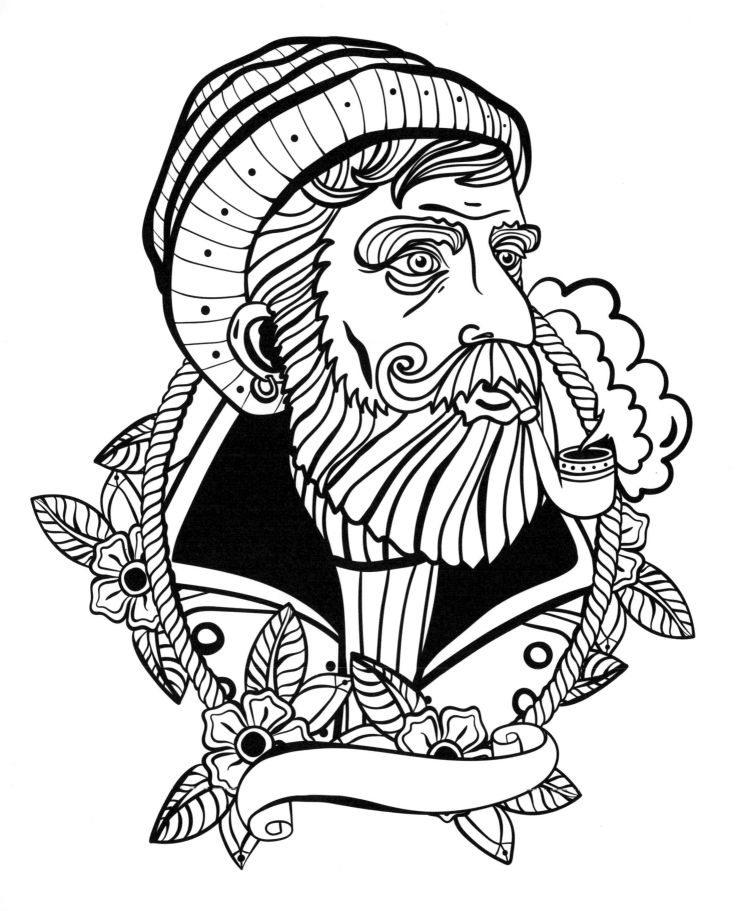

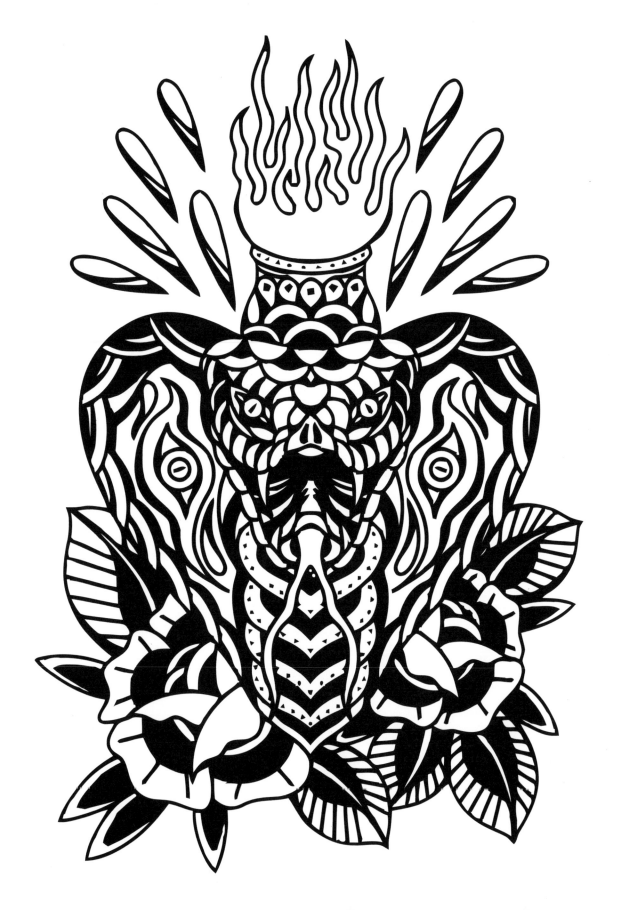

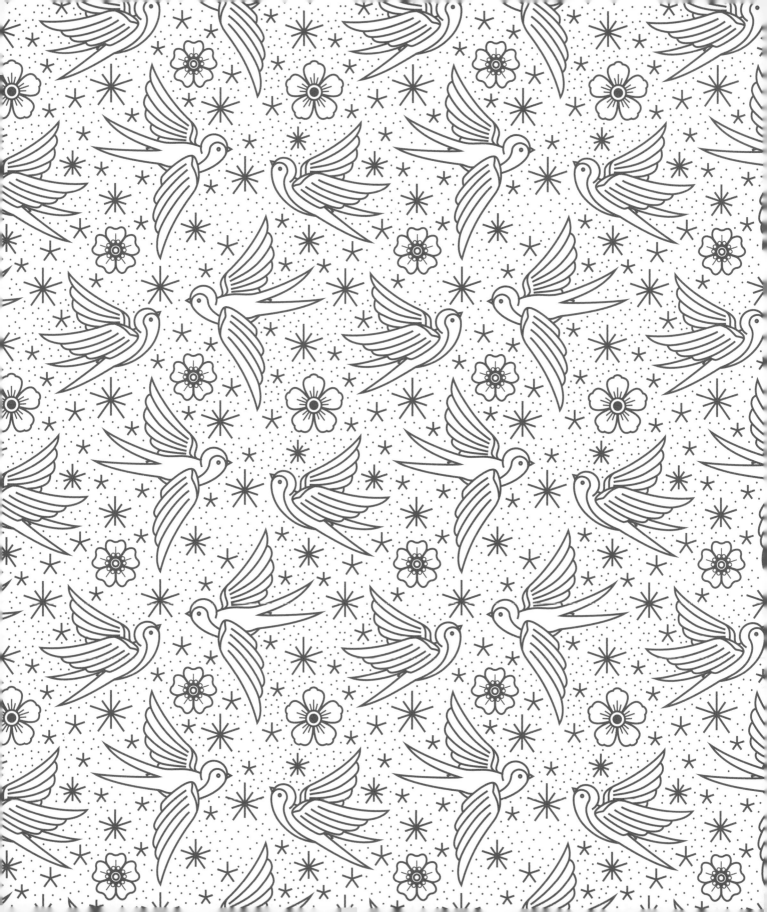

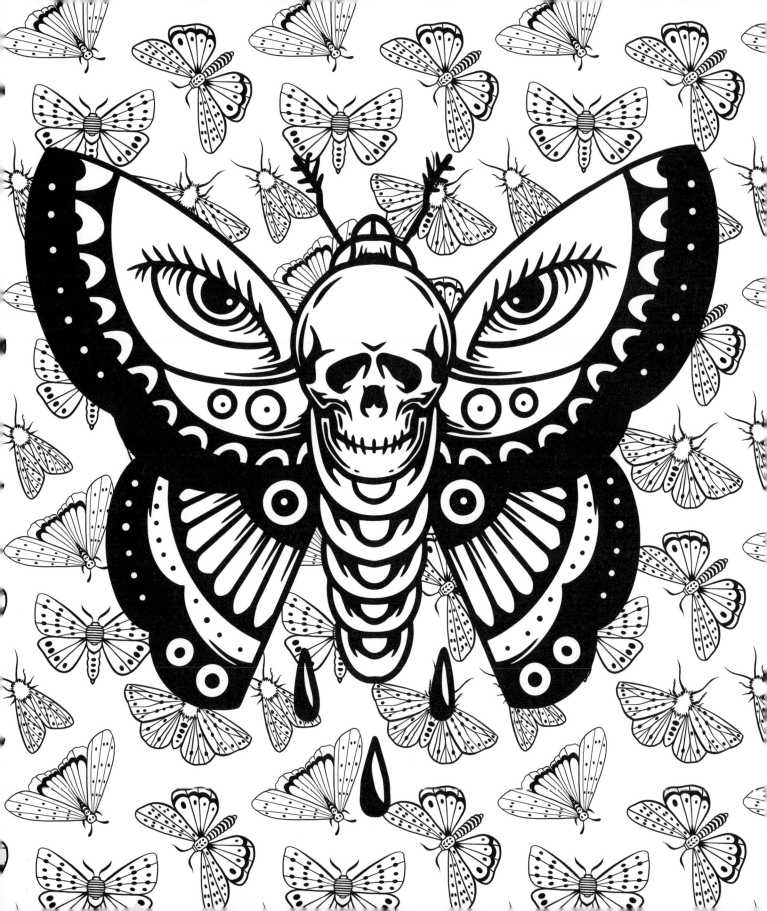

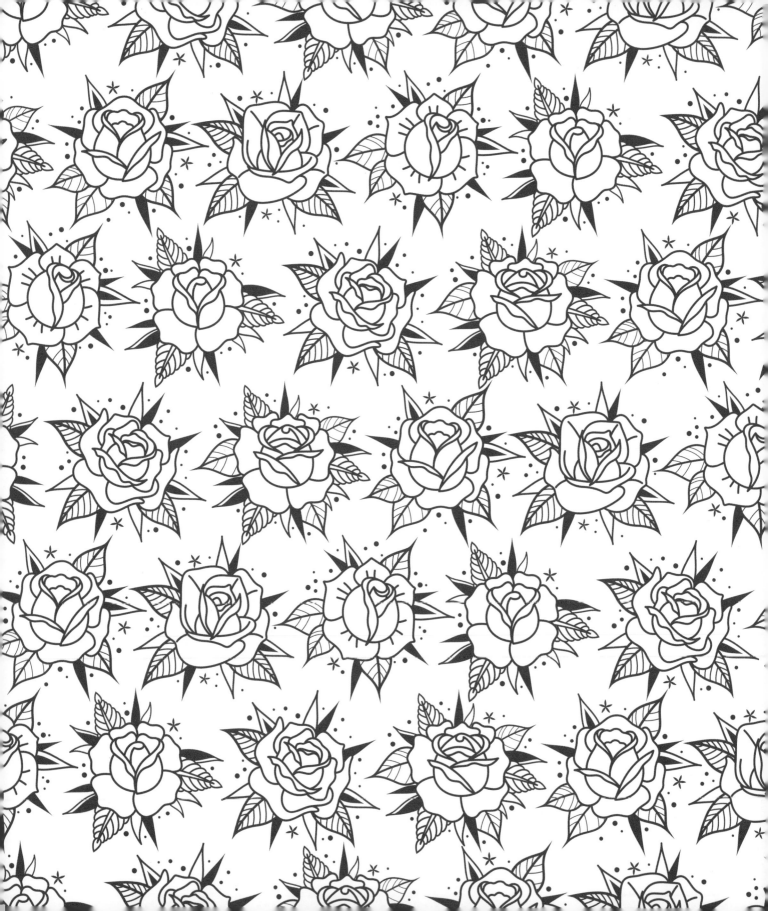

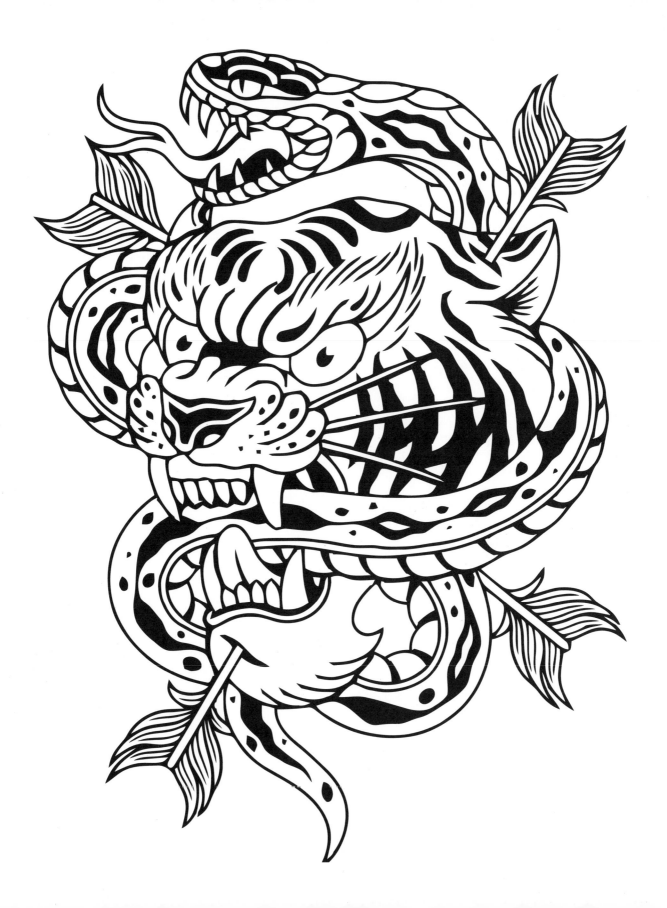

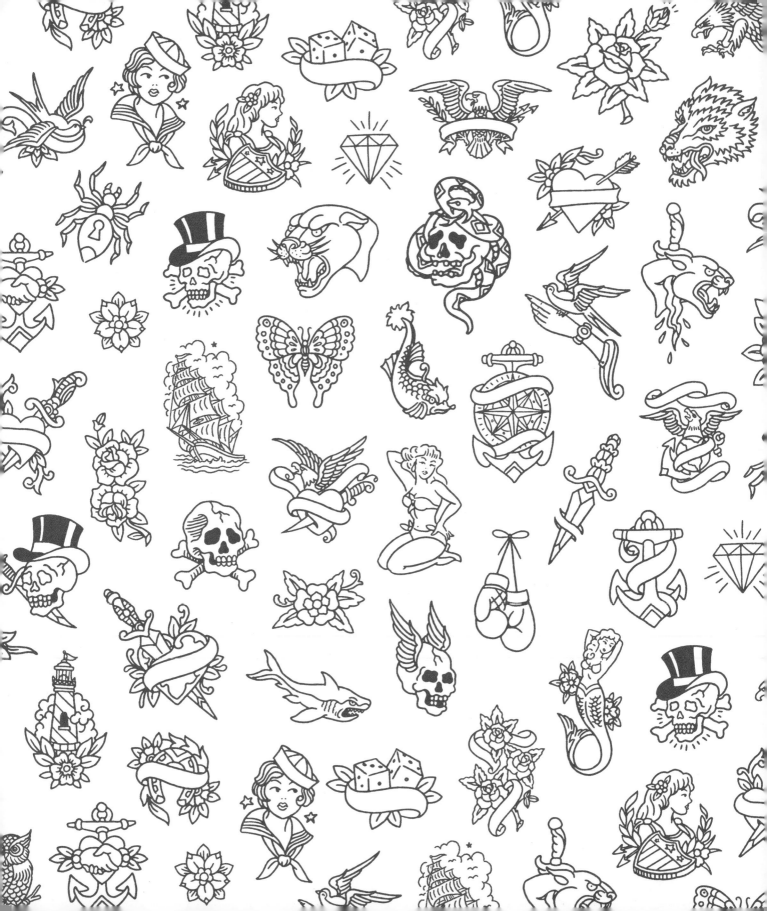

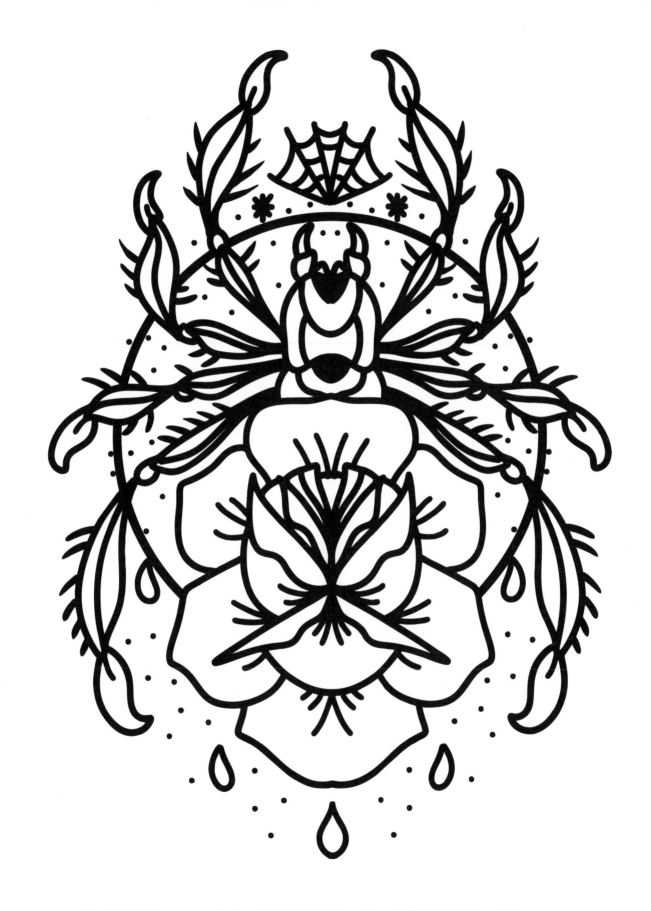

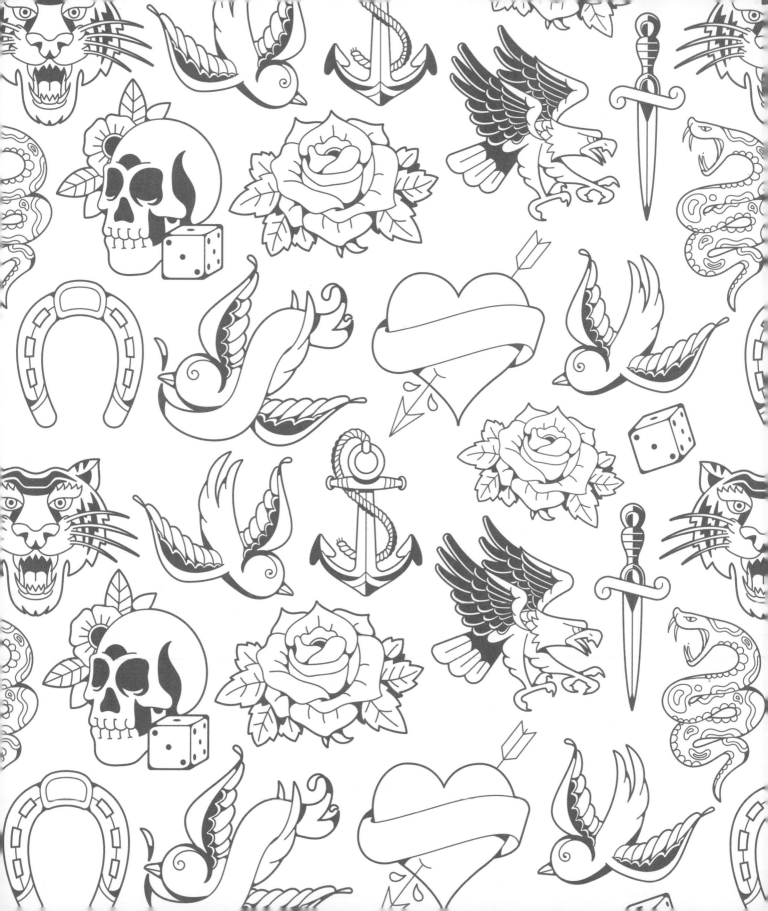

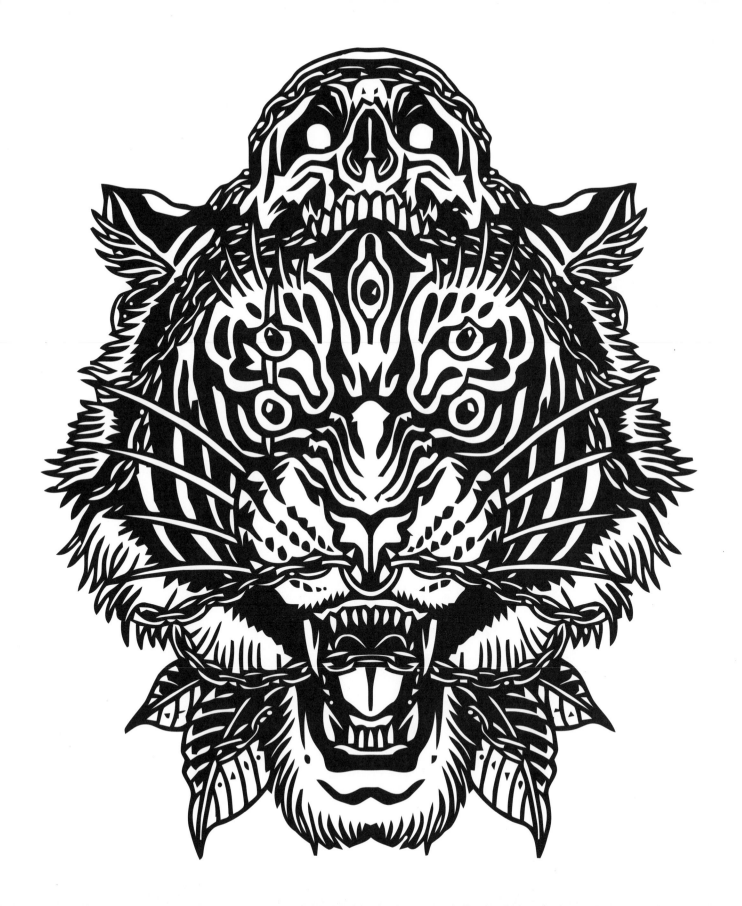

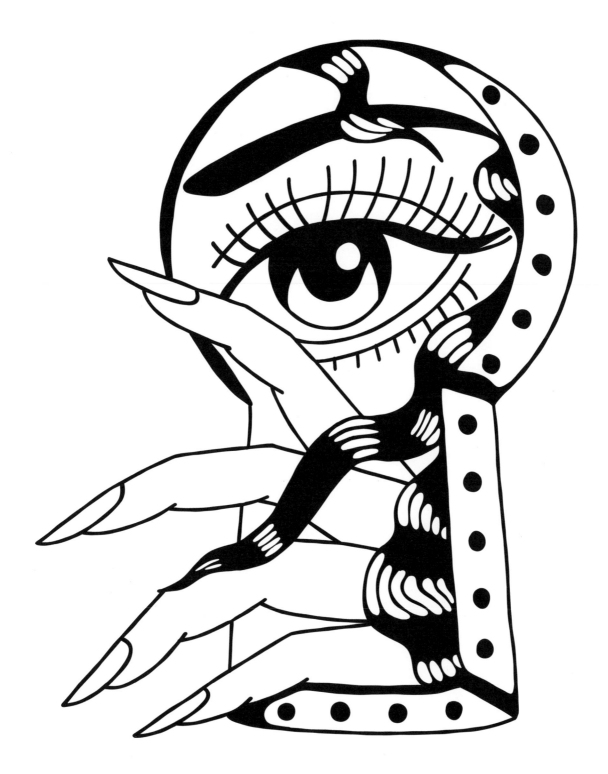

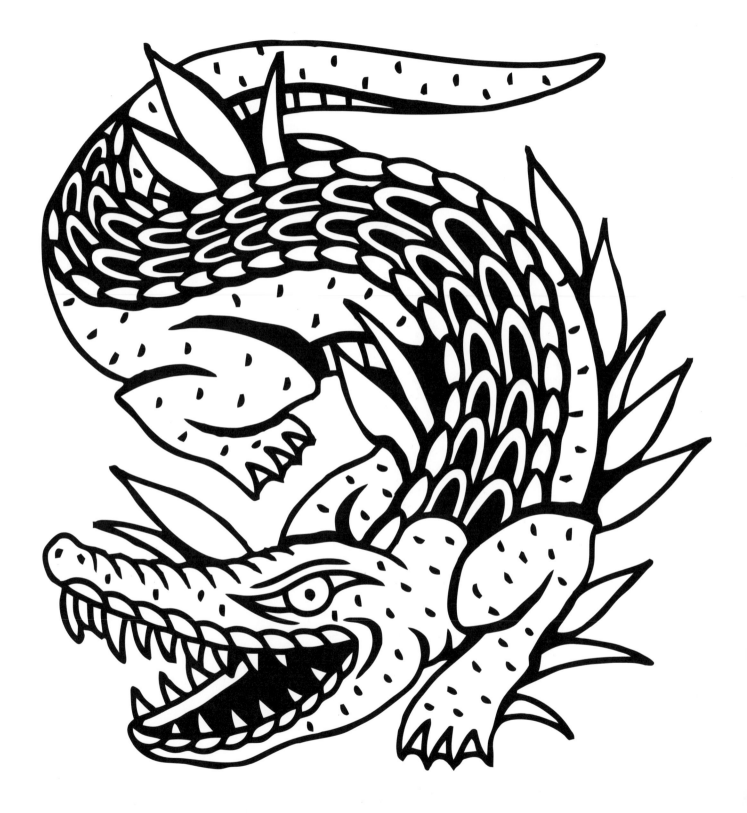

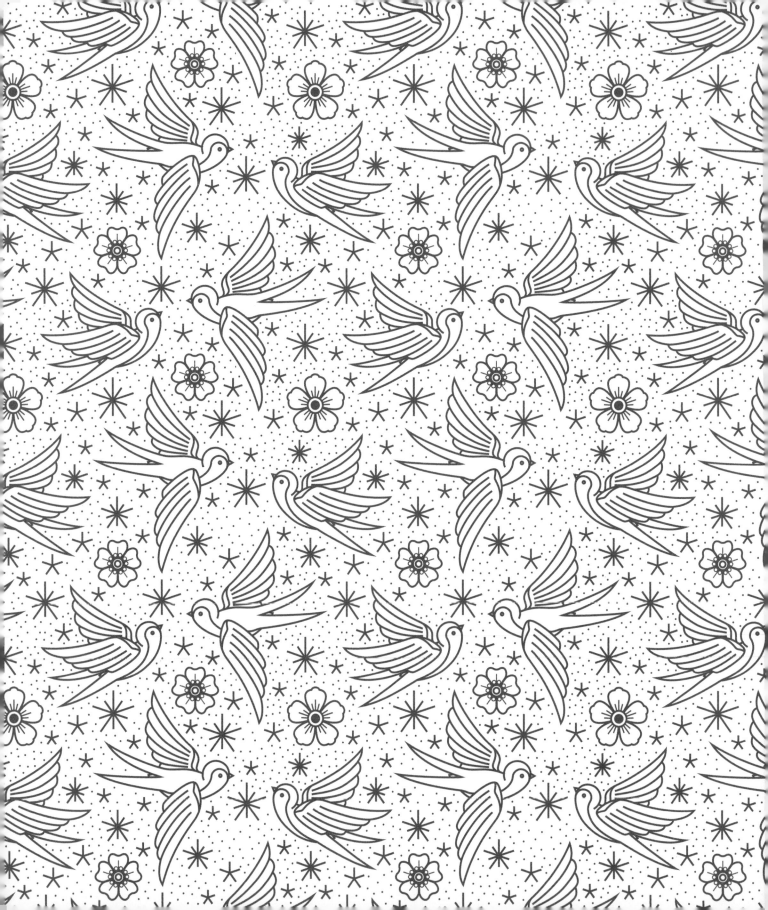

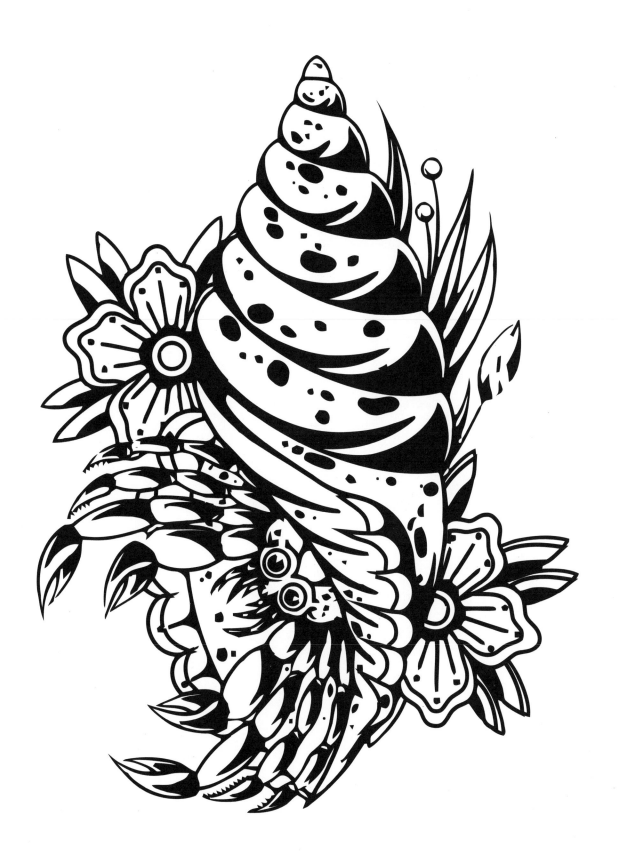

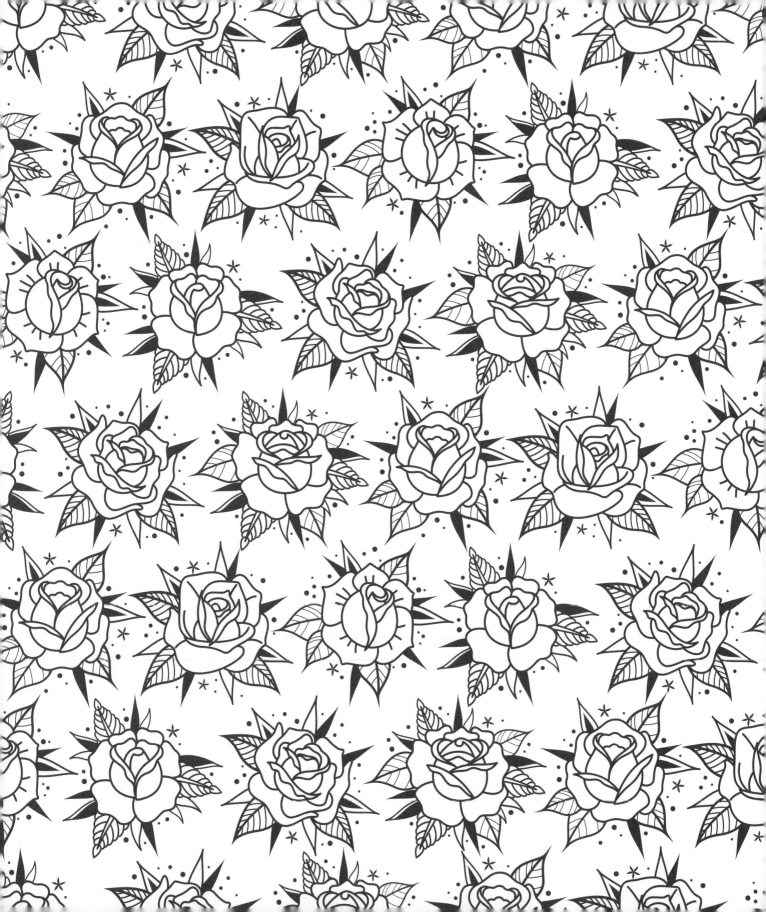

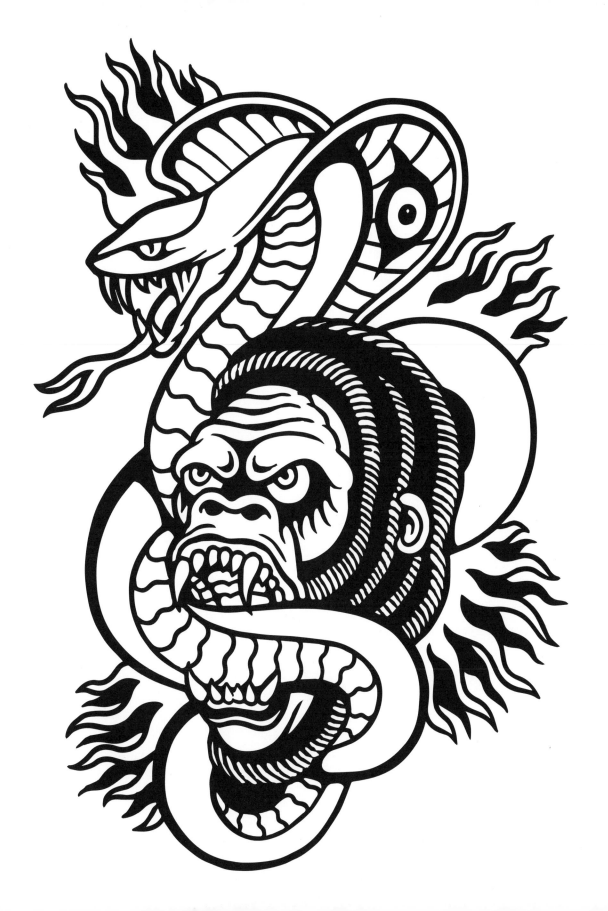

# Quarto

This edition published in 2023 by Chartwell Books,
an imprint of The Quarto Group
142 West 36th Street, 4th Floor
New York, NY 10018 USA
T (212) 779-4972 F (212) 779-6058
www.Quarto.com

10 9 8 7 6 5 4 3 2 1

Chartwell titles are also available at discount for retail, wholesale,
promotional, and bulk purchase. For details, contact the Special Sales
Manager by email at specialsales@quarto.com or by mail at The Quarto
Group, Attn: Special Sales Manager, 100 Cummings Center Suite 265D,
Beverly, MA 01915, USA.

ISBN: 978-0-7858-4331-3

Publisher: Wendy Friedman
Senior Publishing Managing: Meredith Mennitt
Senior Design Manager: Michael Caputo
Designer: Kate Sinclair
Editor: Jennifer Kushnier

All stock design elements ©Shutterstock

Printed in China